Fine Art Tips

with Lori McNee

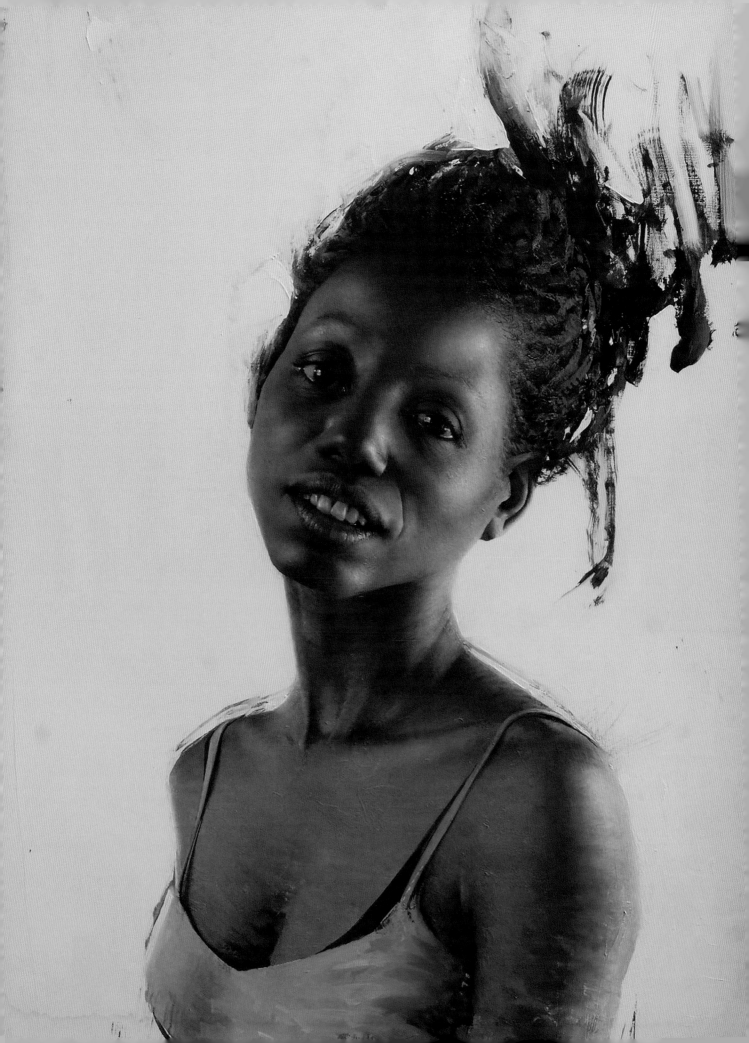

Fine Art Tips

with Lori McNee

Painting Techniques
& Professional Advice

Ketsia
Daniel Sprick
Oil on canvas
26" × 18" (66cm × 46cm)

NORTH LIGHT BOOKS
CINCINNATI, OHIO
www.artistsnetwork.com

Contents

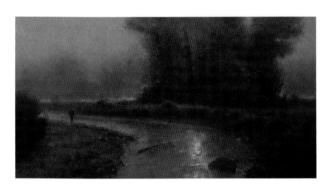

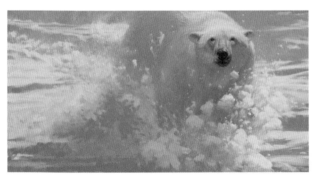

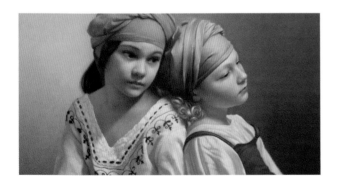

Foreword

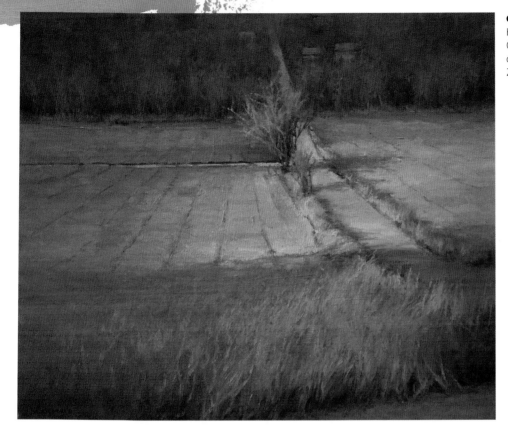

Curve in the Road
Kim Casebeer
Oil on linen mounted
on Gatorfoam board
20" × 24" (51cm × 61cm)

I've been an editor at *Southwest Art* magazine for more than two decades now, which means that I've seen more paintings than I could possibly count. But for all of my experience viewing the finished products, I very rarely see the steps that go into the making of a painting. That process used to be a bit of a mystery to me—my background and training is in writing and editing, you see, not in art-making. One day, though, a small part of the process "clicked" for me when I sat down next to an artist friend as she was about to start a still-life sketch of fruit on a table. She had already offered to teach me some of the basics of painting, assuring me that it wasn't as daunting as I might think. After she secured a piece of pastel paper to her easel, she picked up a neutral pastel stick, held it parallel to the paper, and made a light impression using a few circular strokes. "There," she said. "That's the beginning of your plum. Simple as that." It was an "aha" moment for me, when I understood in a very concrete way what it means to begin with basic, broad, blocky shapes rather than with a perfectly accurate, detailed drawing.

The book you have before you offers page after page of insights that are a little bit like that—glimpses into the working habits of two dozen talented painters that can offer you new ways of understanding the creative process. Whether you favor landscapes, still lifes, portraits, or wildlife, there's something here for you. If you paint in oil or acrylic, watercolor or pastel, there are tips you can use. And these insights are coming from some of the top artists in today's representational art world: Many of them have been featured in the pages of *Southwest Art*, in prestigious invitational exhibitions, and on the walls of respected art galleries. Without a doubt, they're the ones you want to learn from—and they're all right here in one place, offering you a wide array of helpful advice from which you can choose the ideas and concepts that work best for you.

The artist who brought all this useful information together, Lori McNee, is perfectly suited to the task. For starters, she's an accomplished artist herself; I first saw her work more than a decade ago while visiting a gallery in Jackson, Wyoming, and she was featured in *Southwest Art* soon afterward. Since then she's gone on to create a popular blog, FineArtTips.com, where she shares advice and guidance from fellow professional artists on all kinds of topics. Now she's tapped that network of successful painters to share their secrets with you—and I'm sure you'll find within these pages some "aha" moments of your own.

Kristin Hoerth
Editor in Chief, *Southwest Art* magazine
Broomfield, Colorado

Introduction

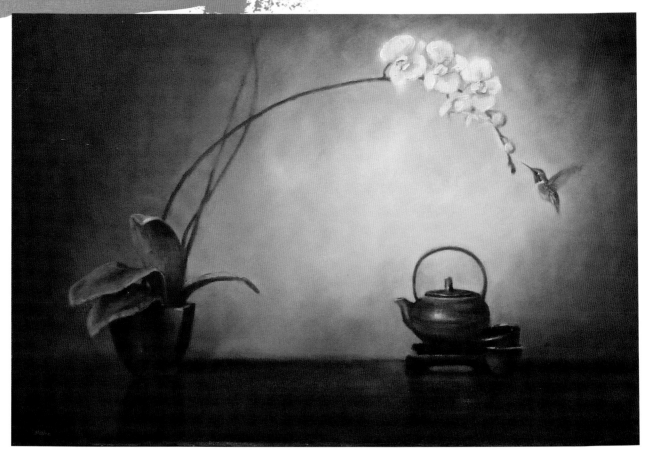

HAVE YOU EVER BEEN IN THE PRESENCE of a masterful painting and, with awe, wondered how the artist created it? What was the artist thinking? What mysterious steps did she take to execute this superb work of art? If you've ever had questions like these, this book is for you.

When asked to write for North Light, it seemed only natural to pattern a book after my popular art blog, FineArtTips.com. Honored, I wanted to use my new book as another opportunity to expand the minds of my fellow artists.

Since 2009, I have been sharing fine art tips, business and social media advice for the aspiring and professional artist. With this as my blog's mission, I have showcased valuable art tips, demos and business guidance by many of today's finest artists, up-and-coming talent, social media stars and business professionals within the art world and other niches.

Using social media, I have networked and made invaluable real-life connections with some of the top influencers in the art world and beyond. For this inventive book I have personally selected twenty-three highly respected, diverse, fine artists whom I admire and connect with using social media.

Working to complete this book has been both an honor and a challenge. This complex project has been like piecing together a beautiful mosaic. Professional artists are busy yet free-spirited people. Many of them work long but random hours, travel a lot and create in seclusion. Some prefer to be reached by email, others by telephone or texting and of course many prefer Facebook.

A project like this would have been nearly impossible only a few years ago. But because of the Internet I can connect with friends and colleagues from all over the world. Needless to say, I couldn't have done this alone. In the end, we all pulled together to create this exquisite book.

Now is your chance to peer into the brilliant minds of twenty-three fine art professionals and watch them paint! So please, sit back and enjoy this sacred journey behind the studio doors of today's finest representational artists, and learn their valuable fine art tips, painting techniques and professional advice with me, Lori McNee!

Lori McNee

Tea Time
Lori McNee
Oil on linen
24" × 36" (61cm × 91cm)

What you Need

Supports

½-inch (13mm) Gator board, acid-free foamboard, Ampersand Gessobord, Arches Oil Paper, canvas, Jack Richeson gessoed hardboard, linen canvas, medium-density fiberboard, panel, sanded pastel paper, Sennelier La Carte pastel card (charcoal colored), UArt 400-grit sanded paper

Alkyd Paints

Raw Umber, Titanium White

Oil Paints

Alizarin Crimson, Alizarin Permanent, Asphaltum, Burnt Sienna, Burnt Umber, Cadmium Green, Cadmium Lemon, Cadmium Orange, Cadmium Red, Cadmium Red Deep, Cadmium Red Light, Cadmium Red Medium, Cadmium Red Orange, Cadmium Yellow, Cadmium Yellow Deep, Cadmium Yellow Light, Cadmium Yellow Medium, Cadmium Yellow Pale, Carbon Black, Cerulean Blue, Cobalt Blue, Dioxazine Purple, Flake White, French Ultramarine Blue, Ivory Black, Lemon Yellow, Manganese Blue, Manganese Blue Hue, Naples Yellow, Naples Yellow Light, Olive Green, Payne's Gray, Permanent Alizarin Crimson, Permanent Green, Permanent Green Light, Permanent Rose, Phthalo Blue, Phthalo Green, Quinacridone Burnt Orange, Quinacridone Gold, Quinacridone Rose, Quinacridone Violet, Raw Sienna, Raw Umber, Raw Umber Violet, Sap Green, Terra Rosa, Titanium White, Transparent Orange, Transparent Oxide Brown, Transparent Red Oxide, Turquoise Blue, Ultramarine Blue, Ultramarine Blue Deep, Utrecht White, Van Dyke Brown, Viridian, Viridian Green, Yellow Ochre, Yellow Ochre Pale, Zinc White

Acrylic Paints

Alizarin Crimson, Bismuth Vandate Yellow, Burnt Umber, Burnt Sienna, Burnt Umber, Cadmium Orange, Cadmium Red, Cadmium Yellow, Carbon Black, Diarylide Yellow, Hansa Yellow Opaque, Mars Violet, Naples Yellow, Payne's Gray, Phthalo Blue, Pyrrole Orange, Pyrrole Red, Quinacridone Magenta, Raw Sienna, Raw Umber, Red Oxide, Sap Green, Titanium White, Transparent Viridian Hue, Ultramarine Blue, Van Dyke Brown Hue, Yellow Ochre

Pastels

#305 Spruce Blue NuPastel, Cretacolor Pastel Carré hard pastels (72-color set), Great American Art Works pastels, Pastels Girault, Rembrandt pastels, Sennelier Half-Stick soft pastels (80-color set) Terry Ludwig pastels

Brushes

liner: no. 2

brights: nos. 1, 2, 4, 6, 8, 10, 12

rounds: nos. 00, 01, 0, 2, 3, 4, 8, 10

egberts: nos. 2, 4

filbert bristles: ¼-inch (6mm), 1- to 1½-inch (25mm–38mm), nos. 0, 1, 2, 3, 4, 5, 6, 8, 10, 12, 14

fans: 1-inch (25mm), nos. 6, 12

flats: ¼-inch (6mm), ½-inch (13mm), ¾-inch (19mm), 1-inch (25mm), 2-inch (51mm), 3-inch (76mm), nos. 1, 2, 3, 4, 5, 6, 8, 10, 12, 14, 16, 20

Other Supplies

400-grit sandpaper, alkyd medium, burnishing tool (bone folder, back of spoon, ice pop stick), charcoal pencil, citrus thinner, Cobra glazing medium, Cobra painting medium, cotton swabs, easel, foam makeup applicator, freestanding light stand with 100- to 150-watt bulb, freezer paper, Gatorfoam drawing board, gel medium, glass palette, glass scraper, gray paper palette, latex gloves, light- to medium-grade sandpaper, linseed oil, man-made objects (vases, old bottles, vessels, books, toys, decorative boxes, tables, tablecloths, household items, other uncommon objects), masking tape, medium- to coarse-grit sandpaper, mineral spirits, natural objects (flowers, food, fruits, vegetables, leaves, sticks, nests, eggs, animal skulls), neutral gray Plexiglas palette, odorless mineral spirits or denatured alcohol, palette knives (1-inch (3cm), 2½-inch (6cm), 3-inch (8cm), 3¼-inch (8cm) triangular-shaped), paper palette, paper towels, pencils (H-4B, 6B), rags, sketch paper or sketchbook, slow-drying medium, soft gel medium, soft lead pencil, soft vine charcoal, solvent-free gel medium, spray fixative, spray retouch varnish, toothbrush, toothpicks, tracing paper, traditional oil ground, turpentine, umbrella, vine charcoal, walnut oil, water, white gesso, white glue, wooden stick, workable fixative

Materials Matter

Using the right tools and materials in the correct way can make a big difference in the success and enjoyment of your artistic process. The following pages outline many of the options at your disposal so that you can make the most of your art materials, your time in the studio and your spirit of creative adventure.

Artist Profile: Ed Brickler

Having a conversation with Ed Brickler is like opening up an encyclopedia. This man is a fount of artistic technical knowledge. Not only is Ed a working artist, he is also the Director of Fine Art Education for Canson, Arches, and Royal Talens. When he is not in his studio painting, Ed is busy traveling the country and demonstrating for most of the major art materials companies.

Ed understands that materials matter in order to successfully execute a painting. Because of this, Ed has compiled his extensive knowledge of art materials into the popular book *Making Art: Materials and Techniques for Today's Artist* (North Light Books). Ed was kind enough to share tips from his book in the following pages. This information was selected to suit the needs of the aspiring and professional fine artist. Parts will be a refresher course to some, but many of you will also find valuable information on new art materials and mediums.

edbrickler-artist.com

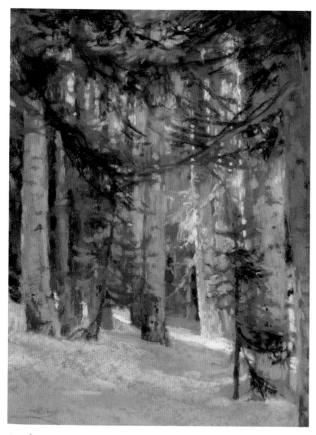

Surface Dance
Christine Debrosky's finishing strokes are like a delicate dance across the sanded paper surface. She adds small spots of intense color to achieve the sense of dappled light.

Aspen and Hemlock Lace
Christine Debrosky
Pastel on Wallis Belgium Mist
14" × 11" (36cm × 28cm)

Making Art

The materials information in this chapter is reprinted from *Making Art: Materials and Techniques for Today's Artist* with the kind permission of Ed Brickler and North Light Books. Purchase a copy of *Making Art* at your favorite bookstore or online retailer.

Canvas

Canvas is a textile fabric that is normally stretched over a wooden frame or rigid support. Preferred textiles used in contemporary supports are linen, cotton, polyester and polyester/cotton blends.

Types of Canvas

- **Linen** is the preferred textile for canvas supports because the individual fibers are longer than cotton fibers. It is also considerably expensive.
- **Cotton** is the most widely used textile for canvas supports. It is available in a variety of weights and textures. In high humidity, cotton and linen will sag, then get tight again when the air is dry. This causes the textile to degrade.
- **Polyester and polyester/cotton blends** do not react to humidity. They are nonabsorbent and will not sag like cotton or linen, but they will stiffen in the cold.

- **Jute** is a coarse textile. It is an economical alternative to cotton canvas, but it is very absorbent and not recommended for oil paintings.
- **Pre-primed canvas** is available with a size and/or ground and as either single- or double-primed. A majority of the pre-primed canvases are cotton primed with an acrylic dispersion ground. If your canvas has been pre-primed with gesso, it is good practice to apply another coat to ensure a smooth, flawless painting surface and prevent bleed-through, especially when working with oils. Linen pre-primed canvases with a size and an oil primer are also available. When buying a roll of pre-primed linen, use it up as soon as possible because oil grounds get brittle with age.
- **Pre-stretched canvases** are also very convenient. They are available in many configurations, shapes and sizes and are always pre-primed.

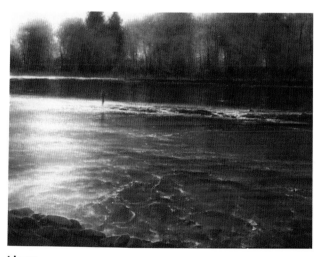

Linen

Brent Cotton loves to paint on linen. By dragging his palette knife across the weave of fine linen, he is able to create the effect of dappled light on water for which he is known.

Symphony of the River
Brent Cotton
Oil on linen
36" × 48" (91cm × 122cm)

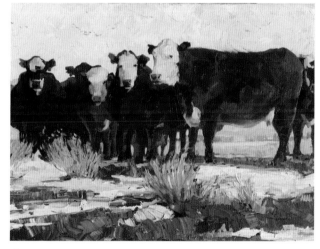

Canvas

The coarser weave of canvas aids Robert Moore's signature style of painting with bold palette knife and brushwork.

Spring Cattle
Robert Moore
Oil on canvas
30" × 48" (76cm × 122cm)

Rigid Supports

Rigid supports can be covered with a specific ground, canvas, paper or even metal. Some can be painted on directly without any sizing or ground. Rigid supports can be used for virtually any medium as long as the medium is compatible with the ground or surface preparation. The biggest limitation of rigid supports is their weight.

Types of Rigid Supports

- **Canvas panels** are made from a variety of rigid supports covered with canvas. The most popular and economical canvas panel is canvas glued to heavy cardboard. Others are canvas on hardboard, wood panels and even Gatorfoam board.
- **Wood panels** are available in various thicknesses and sizes. They can be used in their natural state, but for most paintings, they will need to be prepared with a size and a ground. There are pre-primed wood panels available.
- **Hardboard or Masonite** is a high-density fiberboard. There are two types of hardboards—tempered and untempered. Tempered hardboard is impregnated with an oil or resin and is dark brown in color. Untempered hardboard is a lighter brown and more absorbent. Sanding is not recommended because it opens up the surface. Use a nonsoluble acrylic size first and then apply the ground. Hardboards have a tendency to warp when the panel reaches a specific size, so cradle supports are recommended for panels larger than 36" (91cm).
- **Medium-density fiberboard (MDF)** is a composite of pulverized wood fibers and a urea-formaldehyde resin. It is best to seal the exposed edges of all manufactured wood products. A respirator should be used when cutting or sanding this material to prevent inhaling the dust and resin.

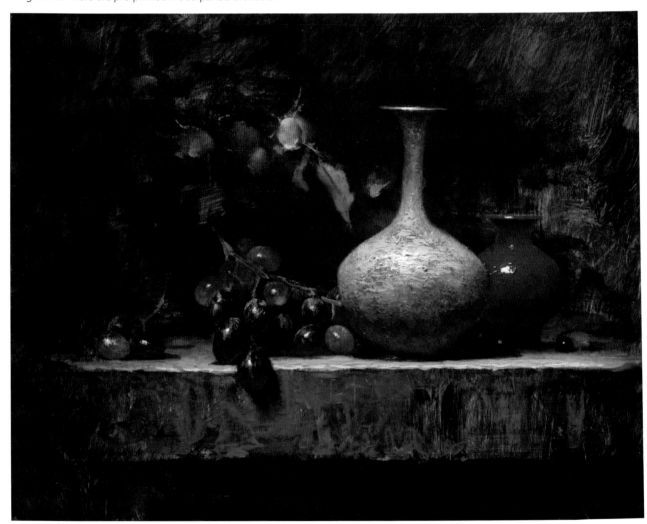

Panel
Oil on panel is the perfect choice for Jeff Legg's elegant still life paintings. The smooth surface of the panel helps Jeff achieve both controlled and spontaneous brushstrokes.

Copper and Red
Jeff Legg
Oil on panel
11" × 14" (28cm × 36cm)

- **Hardbords** are manufactured by Ampersand and are available unprimed or primed with various grounds. They are also available with different size cradles.
- **Paper boards** such as illustration boards, mat boards, watercolor boards and art boards are made by mounting a fine-art paper onto a paper core. They have a variety of textures from ultrasmooth to medium texture for drawing; smooth, cold-pressed and hot-pressed for watercolor; and textured for pastels and charcoal. Paper boards can also be used for mixed media. Mat boards are available in a wide variety of colors for framing but are also a suitable drawing surface. Not all paper boards are acid-free, so choose carefully when making your purchase.
- **Museum and mounting boards** are made from layers or plies of the same paper mounted together. Museum boards are made of 100 percent cotton and are lignin-free. Mounting boards are acid-free alpha-cellulose and can be solid black or black with gray sides.
- **Foamcore board** is paper mounted on acid-free polystyrene foamcore. It dents easily.
- **Gatorfoam board** is a lightweight composite board that is much stronger than foamcore. It is expensive but it is much lighter than hardboard.
- **Multimedia Artboard** is a rigid support that is lignin-free and pH neutral. It is the thickness of a 240gsm (114-lb.) sheet of paper but very durable, making it suitable for both drawing and painting. Unfortunately, it is brittle and can chip or crack if dropped.
- **Perma/Dur** is corrugated board made from lignin-free, 3 percent calcium carbonate buffered alpha-cellulose. It is blue-gray in color and lightweight with superior strength and a smooth surface. It makes an excellent acid-free frame backing or filler board. It is also used for archival storage boxes.
- **Metals** have long been used as painting supports. Since copper, brass and bronze are affected by oxidation, surface preparation is necessary or the painting will peel off the surface. Aluminum does not need the same surface preparation as copper, but it does oxidize. Degrease and sand the surface before adding a ground or painting on the surface directly. In his book *The Painter's Handbook*, Mark David Gottsegen suggests that aluminum is a good substrate for use with acrylic dispersion paints.
- **Glass** is a nonabsorbent support. It is a suitable surface for oils but is not suitable for acrylics.
- **Plexiglas** is a polymethyl methacrylate (PMMA) and comes in a variety of thicknesses. It is a suitable support for acrylics and acrylic mixed media and can also be used as a support for making monoprints. When using Plexiglas, make sure it is free from oil and dust.

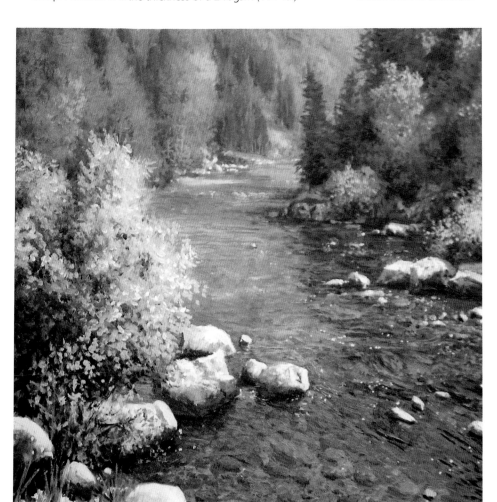

Toned Panel

Michael Godfrey begins with a toned panel for both his studio works and field studies. Panels are lightweight and portable, which make them the preferred support for the plein air painter. The smooth surface of the panel is perfect for Michael's exquisite, detailed landscapes.

And the River Runs Clear
Michael Godfrey
Oil on gessoed panel
12" × 12" (30cm × 30cm)

Papers

Texture is the surface finish of a particular paper and often becomes its fingerprint. Sometimes texture is called the "tooth" of the paper. Texture can dictate which medium should be used on that surface. For instance, pastels and charcoal work best on rough-textured papers, especially when applied in multiple layers. Pen and ink work best on smooth papers, specifically if metal nib pens are being used. For the most part, texture is a personal choice for the artist and part of the creative process and artistic expression.

The terms used to describe texture can be confusing and sometimes cryptic, especially since there are no standard descriptions. Textures are unique to the manufacturer and vary according to the medium. Therefore, it is advisable to collect paper swatch books to keep as reference for future paper choices. You cannot determine if a paper texture will work for you until you use it and experiment with various techniques and mediums.

Sanded Pastel Paper
The gritty, granular sanded pastel paper surface holds the pastel strokes. The inherent texture of the paper plays a part in the final feeling of the painting. Mounted pastel paper helps keep the painting flat, especially when wet techniques are used.

Arancia
Jill Stefani Wagner
Pastel on sanded pastel paper mounted to board
12½" × 25½" (32cm × 65cm)

Oils and Paper

Paper can be used for all mediums except oils because the vegetable drying oil used in oil paints is acidic and will eventually destroy the paper fibers. If you are using oils on paper, it must be primed with additional sizing such as hide glue or an acrylic ground like gesso. However, there are canvas-textured papers that are suitable for oils because of the coating. Arches Oil Paper is a relatively new paper that can also be used with oils without preparation. It is specially formulated with a barrier added to the pulp during manufacturing that protects the cotton fibers from acid.

Varnishing Tips

It is necessary to varnish an oil painting in order to protect the paint film. Since resin is the essential ingredient of a varnish, it is more convenient to purchase a varnish than to make your own. There are traditional varnishes made with traditional resins, the most common of which is damar. There are also modern varnishes made with modern resins.

Modern varnishes are also called picture varnishes, but there are many proprietary names when it comes to varnishes. The best way to distinguish between the two is to check the label. If mineral spirits or petroleum distillate are listed in the ingredients, it is a modern or picture varnish. I prefer modern varnishes because they do not yellow or become brittle, and they are removable with mineral spirits.

The first varnish that should be applied to an oil painting is the retouch varnish. Retouch is a traditional varnish that has a lot of solvent and a little bit of damar resin. It is applied as soon as the oil color is dry to the touch. It's meant to protect the painting and bring all the colors up to an even sheen. It can also be used between the layers of a painting.

After six to twelve months, depending on the thickness of the paint film, a final varnish will need to be applied. A final varnish is also a mixture of a resin diluted in a solvent but is much more concentrated than a retouch varnish.

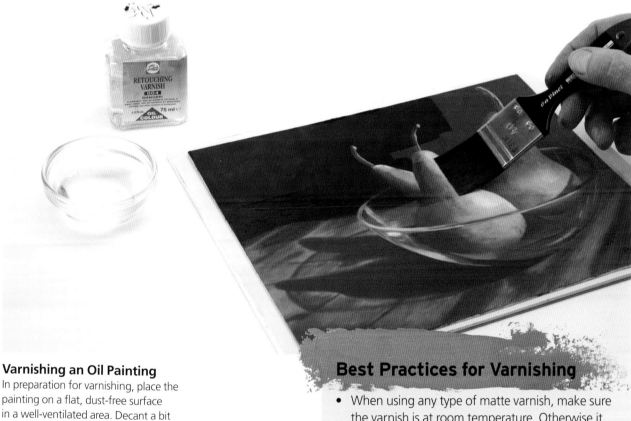

Varnishing an Oil Painting

In preparation for varnishing, place the painting on a flat, dust-free surface in a well-ventilated area. Decant a bit of retouch varnish into a dish and use a large, soft, flat brush to apply the varnish in one direction only. (Here I'm applying it in horizontal strokes.) Clean your brush with turpentine, not mineral spirits.

When it is time for the final varnish, decant some picture varnish into a dish and use a large, soft, flat brush to apply. Use mineral spirits to clean the brush.

Best Practices for Varnishing

- When using any type of matte varnish, make sure the varnish is at room temperature. Otherwise it could bloom, causing shiny and dull spots on your painting.

- Varnishes are also available in spray form. When using a spray varnish, lay the painting flat in a dust-free and well-ventilated area. To prevent puddles and runs, apply a light coat in one direction. Let it dry and then apply another light coat in the other direction.

- A final varnish should always be removable so that a painting can be cleaned or restored later on.

Grounds

A ground, also known as primer, is applied to a support to provide a foundation to the surface that painting or drawing mediums can adhere to. Grounds also provide texture or tooth, as well as a degree of absorbency. For watercolors and some drawing materials, sizing alone may be enough to work as a ground, but nevertheless the ground and the support are integral parts of your artwork. Therefore, the type of ground utilized must be matched with the support.

Types of Grounds

- **Gesso** means gypsum or chalk in Italian. Any ground containing gypsum, chalk or calcium carbonate is considered a gesso. Traditional gesso ground is a mixture of gypsum or chalk and rabbit skin glue. It works well on wood panels and provides a luminous painting surface for egg tempera. However, it is not very flexible because the hide glue-chalk combination becomes very brittle once dry. Because of this, traditional gesso ground should be reserved for use on rigid supports only.

- **Traditional oil ground** has a linseed oil binder, resulting in a unique oil painting surface. Over time, traditional oil ground will become brittle, so it's necessary to size the canvas prior to applying the ground.

- **Modern oil ground** uses an oil-modified alkyd resin as a binder, resulting in a faster drying time and providing a longer period of flexibility than a traditional oil ground.

- **Modern acrylic ground** is the most widely used ground by contemporary artists. It is commonly called "gesso," a misnomer that often causes confusion. It is important not to confuse the modern use of the term with traditional gesso. In modern acrylic ground, acrylic dispersion is used as the binder. This allows for great flexibility to produce a wide variety of grounds for other mediums.

Acrylic Paints

Acrylic paints are a popular choice among wildlife artists. Acrylic dries quickly and helps Suzie Seerey-Lester create the illusion of feathers, fur and fauna using layers of glazes, crisp lines and other textural techniques.

Snowy Sentinel
Suzie Seerey-Lester
Acrylic on panel
18" × 36" (46cm × 91cm)

Sizing With Gel Medium

Acrylic gel medium can be used as a sizing prior to modern acrylic ground for a stiffer canvas surface.

Traditional Oil Ground

Follow along to practice making a traditional oil ground and applying it to a panel. (Note: Sizing is required prior to the application of an oil ground to canvas. PVA sizing is recommended.)

MATERIALS

Support
Wood panel

Brushes
1-inch (25mm) flat

Other Supplies
400-grit sandpaper, palette knife, traditional oil ground, wooden stick

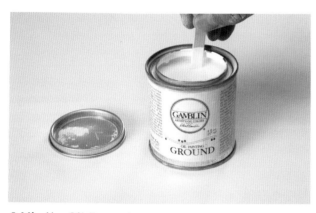

1 Mix the Oil Ground
Stir the container of oil ground with a wooden stick to mix it well.

2 Apply the Ground to the Panel
Use a palette knife to apply the oil ground to the wood panel. Remove or smooth out any lumps.

3 Smooth Out
Smooth out and remove any excess ground with a 1-inch (25mm) flat.

4 Sand Down
Let the ground dry completely, then sand the panel with 400-grit sandpaper. If necessary, apply additional coats and sand lightly between layers for a smooth surface.

Oils

Oils are most commonly sold in metal tubes and available in two types—artist grade and student grade. Artist-grade oils have high pigment strength with the pigments ground as finely as possible. In this grade there is a series of single pigment colors, as well as more expensive pigments such as Cadmium colors, Cobalt colors and Cerulean Blue, which makes it necessary to have series pricing. In essence, the price of the color will depend on the price of the pigment used to make it.

The second range of oils is the student-grade colors. These are also called sketching oils. Manufacturers reduce the amount of pigment in the paint and replace it with inert filler such as aluminum hydrate. This results in a lower pigment strength and hence, a less-expensive oil color. Student-grade oils can vary widely in both range and strength of colors. Usually all colors will be priced the same unless the more expensive pigments such as Cadmium, Cobalt and Cerulean are added to the range.

Fat Over Lean

"Fat over lean" is the quintessential rule of oil painting, especially when painting in layers. Oils dry through oxidation, so each layer of color painted over a previous layer of color must have more oil added to make it "fatter."

Additives

Oil color additives are defined as anything that is added to oil color that will change the fluidity, shine, opacity or drying time of the paint.

Types of Oil Color Additives

- **Solvents:** Two types of solvents are used with traditional oil color—turpentine and mineral spirits. When added to oil colors, solvents create a wash. They are also used for cleaning oil paints from brushes and other painting tools. Solvents are toxic and flammable, so make sure you have adequate ventilation and exercise caution when using them. (Replace solvent with water when using water-mixable oils.)
- **Essential oils:** Essential oils are vegetable drying oils that are highly refined to reduce their acidity. This makes them more expensive but much higher quality than hardware store brands. Linseed oil is the primary vegetable drying oil used as a color additive in oil paints. Other vegetable drying oils are sunflower oil, safflower oil, walnut oil and poppy oil. All these oils have their own characteristics. Linseed oil dries the fastest but yellows the most. Poppy oil dries the slowest but yellows the least. The other oils fall in between. If too much oil is used, the paint film will wrinkle, so a medium is recommended when using essential oils as color additives.
- **Stand oil:** Stand oil is linseed oil that is polymerized by heating the oil in a vacuum at high temperatures, resulting in a honey-like consistency. Stand oil is used to make glazing mediums because it has high luminosity, yellows less and dries faster than all the essential oils.

Mediums

A medium is an oil additive that adds binder to the color. Mediums are also used to change the consistency or fluidity of paint. They can change the sheen of the paint film as well. Essential oils are considered a medium, but mediums can also be mixed additives that contain a binder. Solvents are not considered to be mediums because they don't contain any oil. A simple medium can be a mixture of an essential oil and a solvent. A better medium is a mixture of oil, solvent and a resin.

Resins help stabilize the oil to provide a smoother paint film. Resins can also increase the drying time of oils. Traditional or natural resins used in mediums are damar, copal, mastic, amber, shellac and wax. Modern substitutes for these resins offer a more stable paint film, less yellowing and in the case of alkyd, longer flexibility of the paint film. Kamar, alkyd and solvent-soluble acrylic are just a few of the modern resins in use today. It's important to remember that each resin is diluted and dissolves in a particular solvent. For example, damar works with turpentine but not mineral spirits.

Alkyds

Alkyds are fast-drying oil paints and mediums. The alkyd resin makes the oil dry much faster than traditional oils. Alkyds' main advantage over oil paints is that they may dry to the touch in 12 to 48 hours, and paintings employing fairly thin applications may be ready to varnish within 3 to 4 weeks. Drying times and gloss level vary by brand.

Lori's Fine Art Tip

Water-mixable oils are perfect for plein air painting. No need for toxic turpentine or other solvents; you need only water. Plus, these oils easily clean up with soap and water. Dawn dish soap works great!

Water-Mixable Oils

Water-mixable oils are oil colors in which the vegetable drying oil has been modified to accept water. This allows for mixing and cleaning with water and eliminates the need for toxic solvents. They are great for travel and plein air painting, confined spaces and artists who cannot tolerate solvents. One of the unique features of water-mixable oils is that they can be used with traditional oils. If you maintain a two-to-one mixture of water-mixable to traditional oils, water cleanup is still possible.

This makes it easy to transition from traditional oils to water-mixable oils, or to incorporate the two without the use of a solvent. As with traditional oils, the fat-over-lean principle applies, drying times are comparable and the final painting must be varnished. Water-mixable linseed oil, painting mediums, glazing mediums and gel mediums are also available. The drying times for these will vary per manufacturer.

Water-Mixable Oils
Water-mixable oils helped Lori McNee blend and create this beautiful atmospheric background without the use of toxic solvents. The smooth surface of the panel was perfect for achieving the detail where needed, whereas the tooth of canvas or linen would have disturbed the quiet of this painting.

Liberation—Tibetan Dream
Lori McNee
Water-mixable oil on panel
36" × 24" (91cm × 61cm)

Acrylics

Acrylic colors consist of a pigment ground in an acrylic resin that is polymerized and then dispersed in water. Acrylics dry very quickly by the process of evaporation. They only require water to be diluted and for cleanup.

Because acrylics contain water, they usually dry darker as the water evaporates. This shift in color value makes it difficult to match colors once they have dried. Manufacturers are making great strides in both reducing the amount of color shift and prolonging acrylic drying times. Both Golden Artist Colors and Chroma are now producing "open" acrylics that dry much slower, allowing the artist more time to blend and work the colors.

Acrylics have less pigment than traditional oils. Their main advantage is that they remain flexible after drying, unlike oils, which become brittle with age. Also, it is not necessary to follow the fat-over-lean principle when working with acrylics.

Acrylics are produced in a wide range of colors and types (viscosities) including fluid, light body, heavy body, extra-heavy body and slow-drying. These are available in tubes and jars in a variety of sizes.

Mediums

The primary purpose of an acrylic medium is to increase the binder in the acrylic color. Additional uses for acrylic mediums are to change:

- the fluidity of the color by thinning or thickening
- the sheen, making it more glossy or matte
- the drying time
- the texture
- the flexibility
- the paint film
- the pigment strength when used as an extender

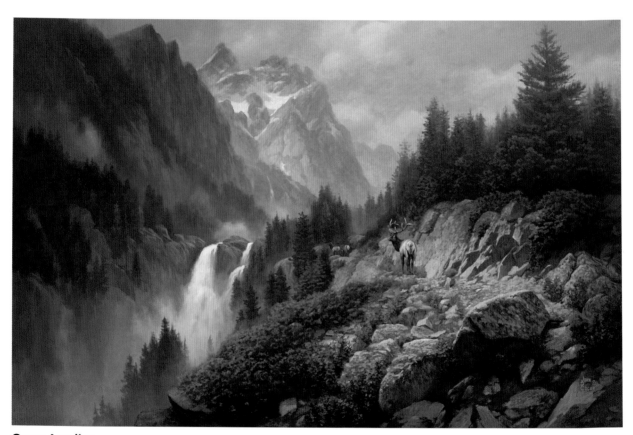

Open Acrylics
John D. Cogan enjoys the advantages of the longer drying time while working with open acrylic paints. He can achieve the look of an oil painting without having to adhere to the fat-over-lean rule. Open acrylics mix with traditional acrylic paints, but this will speed up the drying time.

Inspiration Point
John D. Cogan
Open acrylics on stretched canvas
24" × 36" (61cm × 91cm)

Visit ArtistsNetwork.com/Fine-Art-Tips-Lori-McNee for FREE bonus materials.

Pastels

Pastels are water-soluble and consist of pigment and a water-soluble binder. The binder accounts for the softness or hardness of the pastel, and these vary by manufacturer. They are available in stick form, pastel pencils and PanPastels (an ultrasoft pastel in a cake-like pan format with very low dust).

Most of the pigments used in artist-grade pastels are lightfast. They are made in a large range of color consisting of the pure color, shades and tints. Usually there is a numerical designation associated with the color number that indicates its category. This information can be found on the manufacturer's color chart.

Since pastels can be dusty, take precautions to prevent yourself from breathing in the dust. Manufacturers stopped using toxic pigments in pastels many years ago, but it is always good practice to know exactly what pigments you are using and follow any health and safety warnings listed on the label.

Hard pastels: Hard pastels can give you sharp lines and crisp edges. Their coverage is light and somewhat transparent. Hard pastels are best for composing your design, then can be layered over with soft pastels.

Soft pastels: Soft pastels go on like butter and can give totally opaque coverage. They can be layered almost infinitely (depending on the surface) and blended with blending tools. They are also excellent for finishing details and highlights.

PanPastels: PanPastels can be applied with Sofft sponges or other Sofft tools. They're very smooth, ultrasoft and low-dust. Blending and maintaining soft edges is quick and easy.

Pastel pencils: Pastel pencils are ideal for fine linework and details. It's like drawing with a colored pencil. Pastel pencils can be sharpened with a regular pencil sharpener.

Oil Pastels

Oil pastels consist of pigment mixed with wax and nondrying oil as the binder. Unlike traditional pastels, however, they are not dusty. Because oil pastels are made with nondrying oil, they must be framed under glass. They are also very sensitive to heat and should be kept out of direct sunlight. Varnishes specifically made for oil pastels help protect the surface and reduce the effects of heat.

Wallis Paper
Christine Debrosky chose to work on Wallis paper, which is solvent and water-resistant. This support is a good choice for Christine's technique that begins with a watered-down acrylic wash.

Homestead Sentinels
Christine Debrosky
Pastel on toned Wallis paper
20" × 24" (51cm × 61cm)

Jill Stefani Wagner's Fine Art Tip

Try layering pastels over a dry watercolor underpainting for a great effect.

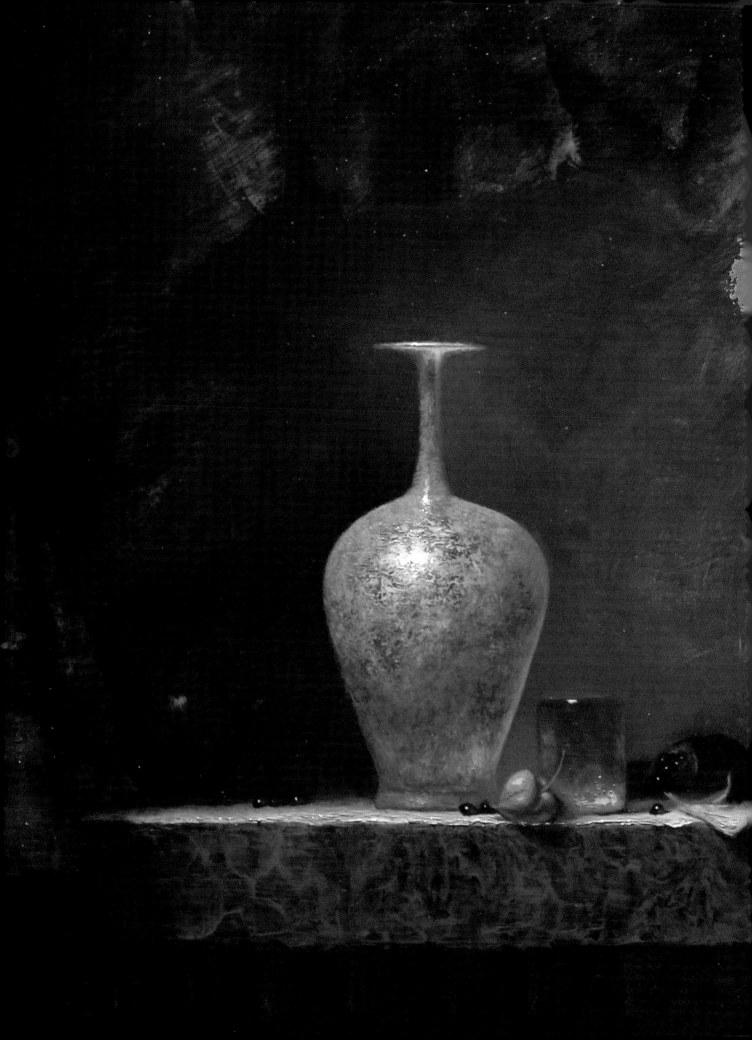

Still Life

Artists have been creating still-life paintings of ordinary objects for thousands of years. It might be hard to believe, but still-life paintings have played an important role in history. Like windows to the past, these paintings documented everyday life before the invention of the camera.

Commonplace items in a still life are generally artificial objects that do not move, such as vases, household items and books, hence the word "still." They also include objects that are natural, such as flowers, animals and food, therefore representing "life."

The joy of painting a still life is in creating your own small universe. Still-life painting gives the artist more freedom in the arrangement of elements within a composition than in landscape or portrait painting.

Often, still-life paintings have a deeper meaning. For instance, in many sixteenth- and seventeenth-century paintings, a cut flower or decaying fruit symbolized mortality. The "vanitas" painting style held a symbolic message. Today, with the proper use of lighting and composition, artists can transform ordinary objects into an exciting work of art.

Still-life painting is a wonderful discipline for any serious artist. But too often we struggle with lackluster arrangements. The following pages will help inspire you and take your still-life paintings to the next level!

Effulgent
Jeff Legg
Oil on board
20" × 16" (51cm × 41cm)

Still Life Inspiration

Still-life painting can be an exciting discipline. Yet, choosing the right subject matter to paint is sometimes a challenging task. Even advanced painters find themselves lacking in inspiration from time to time. This chapter illustrates some diverse examples of still-life painting for your own creative inspiration.

Lilies
Robert Moore
Oil on canvas
24" × 30" (61cm × 76cm)

Autumn
Joe Anna Arnett
Oil on linen
22" × 26" (56cm × 66cm)

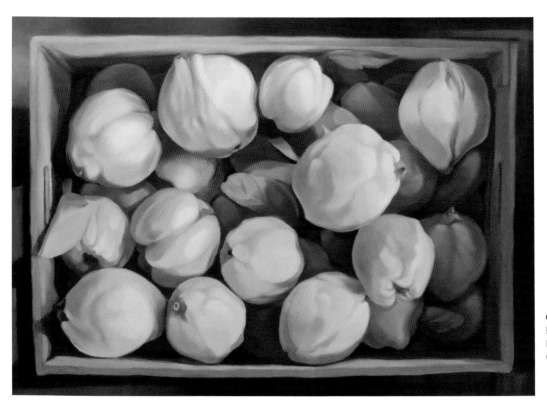

Quinces, Crated
Robert K. Carsten
Pastel on Sennelier La
Carte pastel card
18" × 26" (46cm × 66cm)

Bickley Commission
Jeff Legg
Oil on board | 21" × 30" (53cm × 76cm)

Shades of Gray
Lori McNee
Oil on linen
24" × 18" (61cm × 46cm)

Dahlias
Elizabeth Robbins
Oil on linen
20" × 16" (51cm × 41cm)

Setting Up a Successful Still Life

Years ago in art class, I associated the discipline of still life with mundane drawing exercises of Styrofoam cones and balls. Still life has been defined as "anything that does not move or is dead." This is why I decided to add "life" to my still-life paintings. My favorite Dutch masters mixed birds and bugs into their still life paintings. So why couldn't I? Too often we can find ourselves struggling with lackluster arrangements. Knowing how to properly set up a still life will help take your painting from dull to lively.

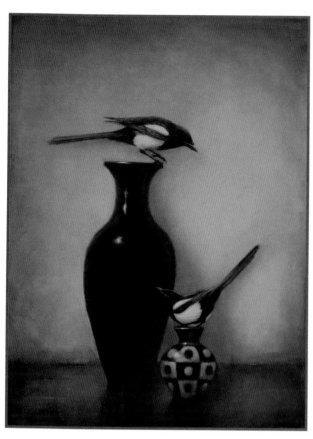

1 Begin With the Concept

Ask yourself: What do I want to say? What emotion do I want to portray? The concept for *Yin Yang* began with the relationships between black and white, hard and soft, stillness and energy. This simple concept also represented a time in my life when I was looking for balance. Consider expressing your own emotions through still-life painting.

Yin Yang—Magpies
Lori McNee
Oil on canvas
40" × 30" (102cm × 76cm)

MATERIALS

When setting up a still life the possibilities are endless. Here are some options:

Natural Objects
Flowers, food, fruits, vegetables, leaves, sticks, nests, eggs, animal skulls, rocks, feathers

Man-Made Objects
Vases, old bottles, vessels, books, toys, decorative boxes, tables, tablecloths, household items, uncommon objects

Still-Life Setup Tips

Follow these tips for more successful still-life setups:

- Avoid kissing objects (items placed too close and touching each other). Remedy the problem by overlapping the objects or create a larger space between the items.
- Make sure the objects can be conveniently arranged on a table.
- Think about your backdrop or background. Even a simple background takes planning. A tone that contrasts with the subject is usually a good choice, or choose a drapery, patterned tapestry or architectural element.
- Keep in mind that glass and other transparent objects, or reflective items such as brass, copper or other metals, are tricky to paint.
- In our Western culture we read from left to right. This is why a still-life painting with the light source originating from the left is very comfortable on the viewer's eyes.
- A north-facing window has the most consistent natural light. If northern light is not available, covering the window with a sheer drape will emulate north light. This will help soften shifting shadows as the sun moves during the day.

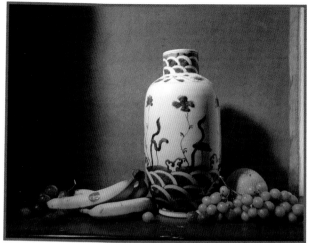

2 Create the Setup

As a rule, most anything can be a subject for a still-life painting. Keep in mind that it is easier to work with familiar objects such as fruits and vegetables or flowers and vases. Think about the mood you wish to portray and the colors of the objects you select. Harmonious arrangements will be more pleasing and restful, while clashing items or colors will cause unease for the viewer. When arranging your still-life setup, consider telling a story. For example, fruit spilling from a bowl, cut in two, or half-eaten and on the table is more interesting than a perfect, untouched arrangement.

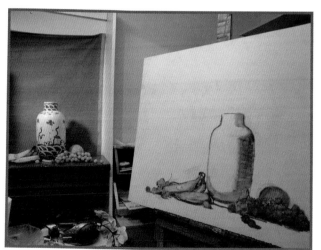

3 Develop the Perspective

Do you want to paint while sitting or standing up? Arrange the still-life objects to match your view. Consider the placement of the objects. Will you be looking down at the arrangement, up at it or at eye level? The perspective can be linear (left to right), foreshortened (front to back) or even more complex. Set it up so you can easily see the setup and your canvas without having to turn your head too much. You want to easily shift your eyes back and forth between your subject and the canvas. If you are right-handed, it is most comfortable to have the still-life setup to the left of your easel, and vice versa. This way your painting hand and brush won't get in the way of your view.

Artist Profile: Lori McNee

"I would like to paint the way a bird sings."
—Claude Monet

For me, still-life painting is like a timeless cashmere sweater—warm, nostalgic and familiar. The joy of painting a still life is that I am able to create my own small universe. Outside Mother Nature is in charge, but in my studio I am the boss!

My arrangements almost always include birds, butterflies or other animals. Often metaphorical, these paintings are a juxtaposition of man-made and nature-made objects that echo the delicate balance between nature and man.
lorimcnee.com

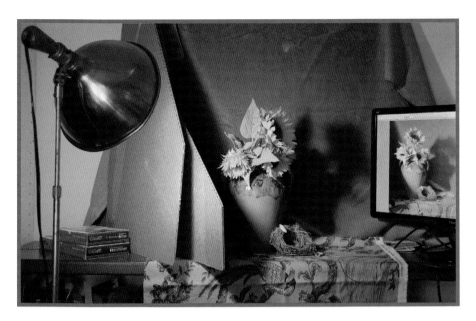

4 Fix the Lighting
It is important to think about the light and shadows when you set up your lighting. Strong shadows make interesting shapes. I use cardboard cut at different angles to cast interesting shadows.

It is best to use a single light source. A freestanding light stand with a 150-watt daylight corrective bulb works great. Position the lamp to one side and fairly low to create dramatic long shadows. Alternatively, the higher the light source, the weaker the shadow.

Take photographs when painting perishables such as flowers and fruit. But remember, believable color and shadows are more difficult to judge in a photograph. A computer monitor is handy for this purpose.

5 Choose the Palette
An organized palette is essential to a well-executed still-life painting. I use an extended palette, which consists of a cool and warm hue representing each color family. With these colors you can simulate the effects of light and duplicate virtually any still-life subject. Lay out the colors in the same order each time so you don't have to think about your paints. Start with Titanium White closest to your painting hand since you will use white the most. With time you will be able to customize your own palette with pigments that suit your needs. Now you are ready to paint!

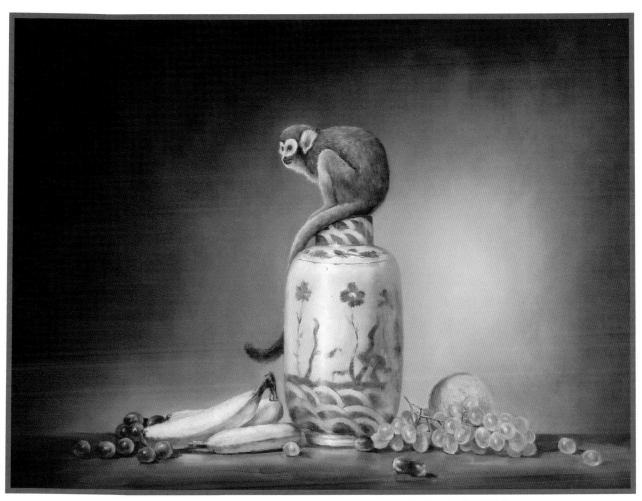

Monkey in the Middle
Lori McNee
Oil on board
30" × 40" (76cm × 102cm)

6 Finalize the Composition

Not centering your subject is a time-honored rule of composition that at times can be broken, as in the case of *Monkey in the Middle*. Most often when you place your subject in the middle, the composition becomes static and boring. When the subject is off-center, it creates tension and dynamic balance, which usually creates a more engaging composition. However, in this painting the carefully planned placement of the fruit along with their shapes and color choices add to the flow of interest. Notice how the tip of the monkey's tail helps to lead the eye up through the composition to the monkey. Most obviously, the title, *Monkey in the Middle*, helped break the non-centering rule!

Lori's Art Business Tip

Always carry business cards!

Seeking the Light in Oil

Apricot and Roses is simply a painting about light, color and the interesting arrangements of shapes. Juxtaposing the warm color of the apricot with the cooler notes of the roses and the Chinese jar are what initially inspired me.

MATERIALS

Support
20" × 20" (51cm × 51cm) stretched linen canvas

Oil Paints
Alizarin Crimson, Cadmium Orange, Cadmium Red Light, Cadmium Red Medium, Cadmium Yellow Medium, Cobalt Blue, Ivory Black, Lemon Yellow, Raw Umber, Titanium White, Ultramarine Blue, Viridian, Yellow Ochre

Brushes
Nos. 0–12 filberts

Nos. 6, 12 fans

Other Supplies
Alkyd medium, odorless mineral spirits, palette knife, rags, slow-drying medium

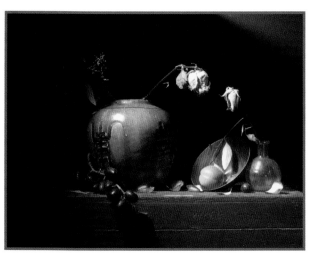

Reference Photo
In this setup, Jeff Legg has chosen a classical approach toward painting the still life with a dark background and the subject illuminated by light.

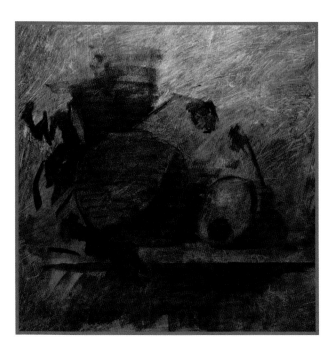

1 Start the Block-In
Tone the stretched linen with Raw Umber mixed with alkyd medium. Wipe it on with a rag and allow it to dry. Next, find rough placement of the large shapes of the objects in the setup. Use a Raw Umber and Ivory Black mixture painted thinly. Use alkyd medium throughout the following steps to make the paint more fluid, dry more quickly and retain its luminous quality. Use nos. 10 and 12 filberts and a no. 12 fan for this step.

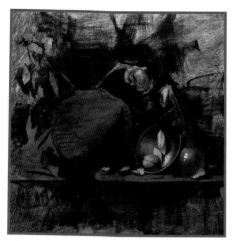

2 Develop the Focal Area
Bring in more background, but leave the edges unfinished like in a vignette. Not finishing everything out to the edges of the canvas allows for some artistic license to create interesting shapes and areas of mystery. Create the focal area of the painting by adding color and form to the apricot. Next, paint the apricot and brass bowl as saturated and bright as possible. Later on you can make adjustments to chroma, temperature and values as needed. Work away from the apricot and add color, but don't paint anything quite as bright and light as the focal area. Use Cadmium Yellow Medium, Cadmium Red Light and Lemon Yellow in the light side of the apricot. Paint Ivory Black, Cadmium Orange and Cadmium Red Medium for the shadow of the apricot. Use Yellow Ochre, Ivory Black and Titanium White for the brass bowl. Paint with nos. 0, 2, 4 and 6 filberts for this step.

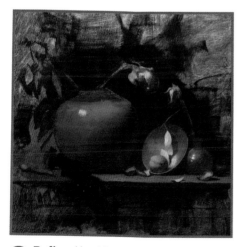

3 Refine the Masses
Make the shapes relate as larger masses before you add the smaller shapes and details. Mix Ivory Black with alkyd medium to make a glaze. Use it and a no. 6 fan to darken the entire background. This will make the colors seem more luminous. Work quickly, as the medium will begin to tack up if you take too long. Adjust the edges of the brass bowl and make its receding edges softer, and the interior of the bowl brighter with a heavier paint applied with a palette knife. Continue to add color and light to the other objects while refining the shape and form, using nos. 6, 7 and 8 filberts.

Artist Profile: Jeff Legg

Jeff's still-life oil paintings are all about light. He believes an object, whether it is a humble pot or an elegant vase, can be elevated to a higher level, even a spiritual perspective. Inspired by the Old Masters, Jeff's contemporary use of chiaroscuro and his choice in subject matter engage his fellow artists and collectors worldwide.

Jeff Legg was born in the Midwest. An appreciator of nature, Jeff spent most of his youth exploring the field and forests nearby. His mother was a talented vocalist, and for Jeff there was a connection between music and art. Jeff studied drawing and painting at the Atelier Lack and Minneapolis College of Art and Design.

Jeff and I originally met online through Facebook. Later, he shared a fabulous painting demonstration as a guest artist on FineArtTips. com. That popular guest post has been shared thousands of times on the Internet. A few years ago, Jeff and I finally met in real life at the Plein Air Convention in Las Vegas, and again at an Oil Painters of America National Exhibition where he was awarded Master Signature status.

jefflegg.com

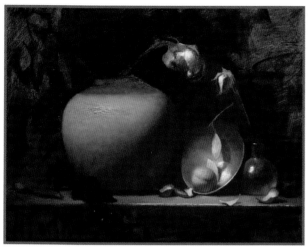

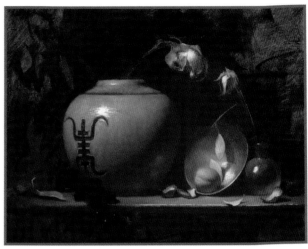

4 Make Changes

Add a leaf on the far left of the table to help balance the composition. Now add some detail to the blue jar and roses. The blue is a glaze mixture with Cobalt Blue, Ultramarine Blue, a little Lemon Yellow and slow-drying medium. Scumble a mixture of Raw Umber, Cadmium Orange, Titanium White and slow-drying medium over the entire jar, allowing the blue underneath to show through. Most of this will be covered over, leaving touches of it showing through. Let dry before going onto the next step.

Note: Midway through the painting, I decided not to include the red wooden box from the original setup. It would overwhelm the other objects in the painting, so I've taken the liberty to make up a different table.

5 Develop Temperature and Value

Now, finish the designs on the jar with Ivory Black and Ultramarine Blue and a no. 2 filbert. Once dry, add an Ultramarine Blue glaze mixture over the entire surface of the jar, allowing the touches of the warm notes to show. All the subtle value and temperature changes worked into the painting add up to "feel" like reality.

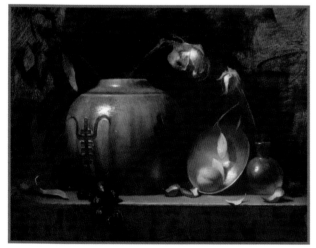

6 Continue the Glazing

Mix a blue-gray color with Titanium White, Cobalt Blue and Ivory Black to use on the grapes. Add enough medium into this mixture to make it semitransparent and give the grapes their form. Apply with a no. 0 filbert. Let the blue-gray disappear as it goes into the shadow side of the grapes. Add the highlights but keep them all different sizes and intensity to add to the realism.

Jeff's Art Business Tips

- An important ingredient to selling paintings in a gallery environment is that the salespeople and gallery owner love your work. If they don't, find a different gallery where they do.
- Having a good gallery is a relationship of trust and loyalty. Always give them your best work, and they will give you their best effort in finding collectors.
- Presentation is everything. Handsome framing, good lighting and the ambience of the gallery are a big part of selling art.

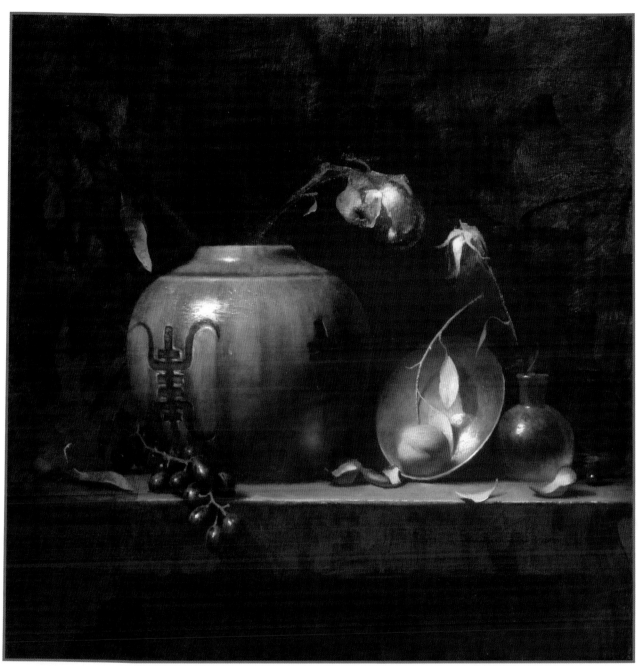

7 Add the Finishing Touches

Add the stem to the grapes and the small leaf stem by the apricot with a no. 0 filbert and a mix of Ivory Black, Lemon Yellow and a touch of Cadmium Yellow Medium and Yellow Ochre. Paint one more glaze mixture of Ivory Black over the background with a no. 6 fan to darken it one more value. This step unifies the whole and makes the colors seem more luminous and complete.

Apricot and Roses
Jeff Legg
Oil on linen
20" × 20" (51cm × 51cm)

Lori's Art Business Tip

Approaching a gallery before you are ready is like putting a gangly teenager in modeling school. It won't help your self-esteem, and it most likely will bruise your ego.

The Secret to Painting White Peonies

Painting white flowers can be a challenge. If you do not add enough contrast between the light and the shadow side, the flower will have no form. Paint the shadows too dark, and the flowers will soon cease to look like white flowers. The key is to balance the contrast carefully and use plenty of luscious overlapping paint strokes in the lights.

MATERIALS

Support
24" × 30" (61cm × 76cm) pre-primed linen canvas

Oil Paints
Cadmium Red, Cadmium Red Orange, Cadmium Yellow Light, Cadmium Yellow Pale, Cobalt Blue, Flake White, Manganese Blue, Permanent Alizarin Crimson, Permanent Rose, Transparent Red Oxide, Ultramarine Blue Deep, Viridian, Yellow Ochre

Brushes
Nos. 2, 4, 6, 8, 10, 12 flats

Nos. 4, 6, 8, 10, 12 filberts

No. 0 round

Other Supplies
1-inch (25mm) and 3-inch (76mm) palette knives, free gel medium (for travel), neutral gray Plexiglas palette, odorless mineral spirits, paper towels, soft gel medium (for the studio), solvent

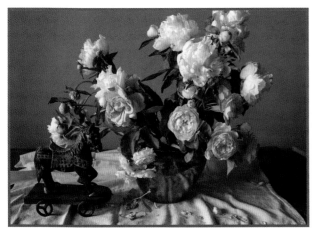

Reference Photo
This painting begins with a setup of white peonies and roses in delicate oranges and yellows. The little carved horse adds an element of whimsy.

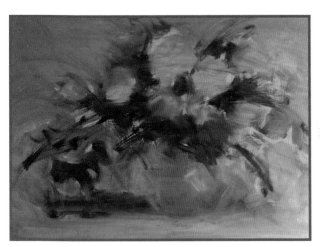

1 Work Out the Placement of Elements
Begin on a canvas toned with Ultramarine Blue and a touch of Transparent Red Oxide plus odorless mineral spirits. Brush the mixture on, wipe lightly with a paper towel and let it dry. Place the elements with colors that will be in the general shadow family. Color at this state is not too important. A no. 10 flat for dark shapes and a paper towel to wipe out the lights work well. This is the first impression and general placement of the elements.

Joe Anna's Fine Art Tip

The more painting you do on a flower, the less fresh it will look. Try to put the strokes down and leave them. If you miss the shape, scrape it and do it again. That is one of the great secrets to painting fresh flowers.

2 Create the Silhouettes

Using only the shadow value and color, put in the silhouette shapes of the peonies with a no. 10 flat. Use Ultramarine Blue Deep, a touch of Cadmium Red Orange and a breath of Yellow Ochre plus Flake White. These peonies have a faint yellow blush toward the deep centers, so push the orange shadow a bit in those areas. Make these shapes as accurate as possible and keep the paint thin because you will later stack lights on top.

3 Begin the Petals

Working wet-into-wet, begin the petals in the light. The mixture is Flake White plus a touch of Manganese Blue and Cadmium Yellow Pale. A no. 8 filbert works well. Where you need a halftone, push the brush in a little harder and drag up some of the wet shadow color beneath.

Artist Profile: Joe Anna Arnett

"Nothing is truly yours until you give it away."
—Joe Anna Arnett

Joe Anna is multitalented and even has a background in commercial art. She was a senior art director for Young & Rubicam advertising and worked on such accounts as *People* magazine and Merrill Lynch.

While in New York, Joe Anna refined her art skills at the Art Students League. Her highly acclaimed, traditional oil paintings have been featured in many museums, galleries and magazines throughout the world. Joe Anna finds inspiration on adventures with her master artist husband, James Asher, as they both love to travel and paint together.

I first met Joe Anna years ago in Scottsdale at one of her popular still-life painting workshops. I learned some oil painting techniques that I still use today. Since then Joe Anna has remained a wonderful mentor and friend.

joeannaarnett.com

Vegetable Soup
Joe Anna Arnett
Oil on linen
20" × 24" (51cm × 61cm)

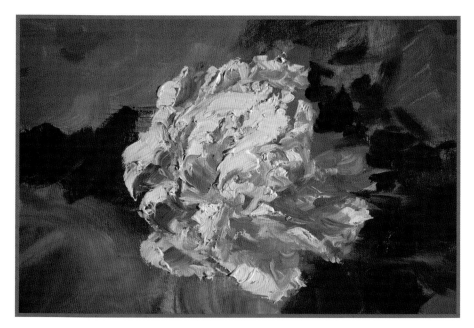

4 Stack the Petals

Using a mixture of Flake White, Cadmium Yellow Pale and a touch of Manganese Blue, load a no. 8 filbert and put each petal down in one stroke. Leave it. If you go back into it and do additional strokes, you will lose the fresh feeling. With thick paint, you can stack petals on top of petals for a fresh, rich look. Don't press down when you do this. The harder you press the brush, the more you will drag into the paint beneath. The petals become a touch warmer toward the center. Add a breath of Cadmium Red Orange to the mixture of Manganese Blue, Cadmium Yellow Pale and Flake White for petals closest to the center. With a no. 6 flat, add a few emphatic darks on the light side where some petals turn using Ultramarine Blue Deep, Yellow Ochre and Flake White.

5 Add Lights to the Next Peony

Using a no. 8 filbert and Flake White and a touch of Manganese Blue mixed with Cadmium Yellow Pale, begin stacking the light on the second large peony. Stacking petal on top of petal works as long as you use thick paint and a light touch. Complete the remaining peonies in the same manner.

Joe Anna's Fine Art Tip

Stacking petal on top of petal works as long as you use thick paint and a light touch. Do each petal in a single stroke. This gives power and authority to the petal.

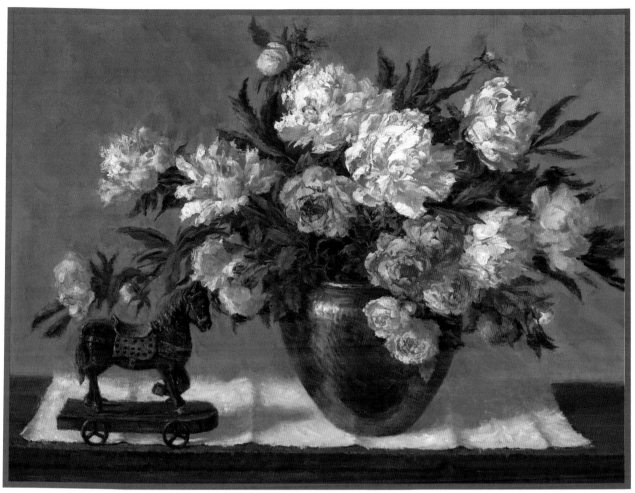

6 Finish the Flowers and Develop the Other Elements

Here is the whole painting with finished groups of peonies, and orange and yellow roses, painted in that order. The yellow roses make for an exciting relationship with the little blue horse, but I placed these roses facing away from the viewer. Too much yellow light in this spot would have taken drama away from the horse's head. Now, with all the flowers complete it's time to slow down and work on the parts of the painting that are more permanent, including the little blue horse.

Little Blue Horse
Joe Anna Arnett
Oil on linen
24" × 30" (61cm × 76cm)
Private collection

Joe Anna's Fine Art Tips

- If you have a good idea for a painting, write it down immediately. It could drift away and you might miss a masterpiece.
- Before you leave the studio each night, decide what you will do the next morning.
- Be yourself. There are so many people today who are working extremely hard toward painting just like somebody else.

Joe Anna's Art Business Tip

Document everything. Keep all art-related receipts and travel documents. You will need these for tax purposes. Be sure to get photographs of yourself, your paintings and locations. The life of an artist is a fantasy to most people and you will need the photos for many uses.

Simple Steps to a Vivid Pastel Floral Painting

Over the last four years, I worked on a series of pastel paintings using recycled objects as subject matter. During that time, I got excited about depicting parts of larger objects and enjoyed using vivid, "pushed" (exaggerated) colors. For a long time prior, my still lifes, mostly of fruit, vases and flowers, explored light effect, contrasting luminous objects against velvety dark backgrounds. *Sweet Summertime* is representative of a current direction in my work, which seeks to reconcile or otherwise adjoin these two different, visual concerns.

MATERIALS

Support
12" × 9" (30cm × 23cm) Sennelier La Carte pastel card, charcoal colored

Pastels
Cretacolor Pastel Carré hard pastels, 72-color set

Sennelier Half-Stick soft pastels, 80-color set

Other Supplies
Gatorfoam drawing board, masking tape, paper towels, pencil, sketch paper

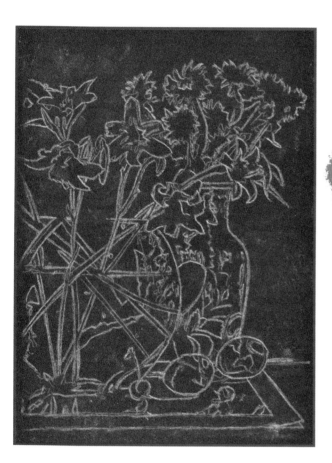

Robert's Fine Art Tips

- Remember, the eye is attracted to contrast, and the "queen" of all contrasts is a strong value contrast.
- First, learn the craft of your art thoroughly. Then don't be afraid to experiment and try new things. Courage is a necessary component of creativity. Explore your subject with childlike curiosity and have complete confidence in your painting process.

1 Create the Composition
The composition is a section of a larger arrangement that has strong lights against dark colors. The still-life arrangement rests on a sheet of glass on top of a colored piece of paper, which adds interesting reflections and color. First, sketch the composition with a pencil on sketch paper, making corrections where necessary. Next, cover the back of the sketch with a light gray hard pastel. Attach the sketch paper, pastel side down, onto La Carte pastel card with masking tape. Transfer the drawing onto the painting surface by gently tracing over the original sketch with a pencil.

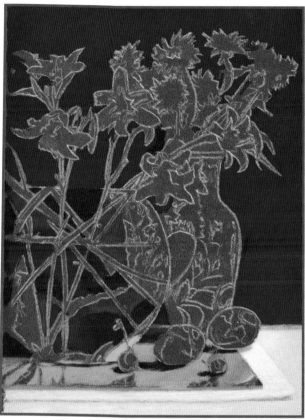

2 Refine the Design

Use hard pastels to block in the large areas of the background, the transparent parts of the clear vase and the foreground. Pay particular attention to the values of the local color.

Next, proceed to the focal point. The Egyptian vase is the center of interest with the lightest lights against strong darks. Paint in that area and adjacent forms, going for a semi-finished look. Note the nuanced color shapes within the objects and the bridging value between the back table edge and the background. Use a variety of hard and soft pastels throughout this portion of the painting.

Lori's Fine Art Tip

Successful artists know their strengths, and that's where they focus their efforts.

Artist Profile:
Robert K. Carsten

"In art, as in life, courage and honesty are needed in great measure."

—*Robert K. Carsten*

An impassioned promoter of pastels, Robert K. Carsten enthusiastically accepted my invitation to contribute to this book. His award-winning pastel paintings range from detailed realism to expressive abstraction in his pursuit of beauty and truth. Robert's illustrious painting career has earned him Master Pastelist status in both the Pastel Society of America and the International Association of Pastel Societies. He is also a popular contributing writer for *Pastel Journal* and *The Artist's Magazine*.

Whether in the studio or out plein-air painting, Robert devotes 6 to 8 hours a day to his art. Also a popular instructor, he teaches over sixty workshops per year. Each day Robert spends time looking at the world from a design perspective, as an arrangement of shapes and colors. Whether in a forest or a city, he formulates and visualizes compositions. This practice brings fresh, new design ideas and inspires creativity in his paintings.

I am pleased to have Robert share his extensive knowledge of pastel painting in this book.
robertcarsten.com

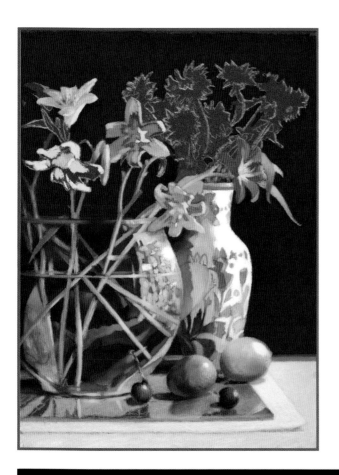

3 Develop the Color and Edges

Next, paint the dynamic diagonals of the stems and the clear vase, blending some of the color transitions with your fingers. Begin the day lilies with hard pastels. Now, paint the reflections in the glass pane, block in the red bee balm flowers and leaves, and continue to refine colors and edges throughout the composition. Use hard pastels for exact edges and soft pastels for vibrant color.

Lori's Art Business Tip

When considering representation with a gallery, be sure to get references from the other artists it represents. Ask if the gallery pays in a timely fashion.

Combining Disciplines

In this painting, Robert K. Carsten combined both landscape and still-life disciplines to make a compelling composition.

Revelation and Insight
Robert K. Carsten
Pastel on Sennelier La Carte pastel card
31" × 23½" (79cm × 60cm)

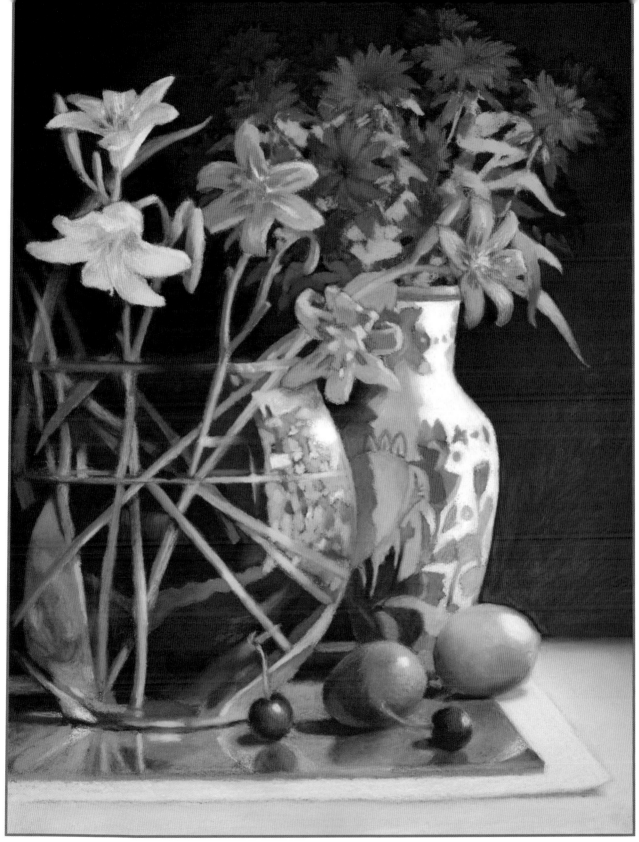

4 Refine the Values

For variation of value, add darker bee balm flowers behind the brighter colored ones. Notice how I darkened the blue of the background on the left and brightened the blue of the background against the Egyptian vase. *Sweet Summertime* is now finished.

Sweet Summertime
Robert K. Carsten
Pastel on Sennelier La Carte pastel card
12" × 9" (30cm × 23cm)

How to Paint Roses

I have had a love affair with roses since my mother gave me the job of weeding her rose garden in our home in Utah. My favorites are the David Austin old English variety. In this lesson I will show you how to develop a rose by simplifying value patterns and introducing temperature changes to give the rose form.

MATERIALS

Support

16" × 20" (41cm × 51cm) oil-primed linen

Oil Paints

Alizarin Crimson, Cadmium Lemon, Cadmium Red, Cadmium Yellow Deep, Cadmium Yellow Pale, French Ultramarine Blue, Ivory Black, Raw Umber, Titanium White, Transparent Red Oxide, Viridian, Yellow Ochre Pale

Brushes

Nos. 4, 8, 12, 14, 28 flats

½-inch (13mm) flat

3-inch (76mm) chip

Other Supplies

Cotton swabs, odorless mineral spirits, paper towels, solvent-free gel medium

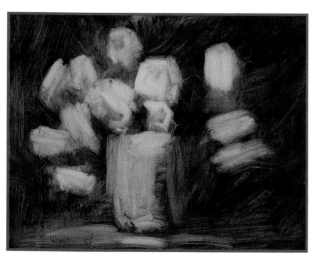

1 Start the Block-In and Wipe-Out

Begin by using a 3-inch (76mm) chip brush that can be found at any hardware store. Thin Viridian and Transparent Red Oxide with a little bit of odorless mineral spirits, and loosely brush on this mixture, making some areas thicker and some thinner to create a thin background look. Continue until the entire canvas is covered. Now take a paper towel and wipe out the areas where the roses will be. You can use a little bit of mineral spirits on the paper towel, which will help in lifting out the color. Use cotton swabs for more detailed areas.

Elizabeth's Fine Art Tip

Spray the lid of your paint tube with cooking spray to avoid gummy paint buildup around the opening.

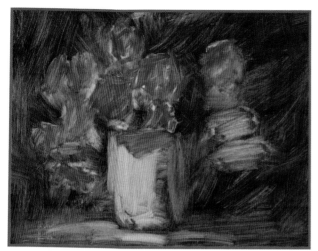

2 Add Color
With a ½-inch (13mm) flat, lay in a thin application of Alizarin Crimson in the areas you just wiped out. Thin the paint by adding a bit of mineral spirits.

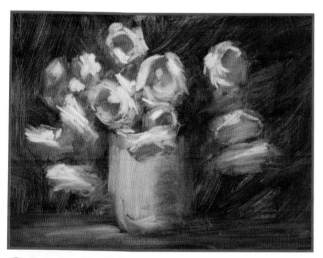

3 Develop the Value Underpainting
Using a paper towel or cotton swab, rewipe out the areas where the light hits the roses, leaving a suggestion of light and shadow.

Elizabeth's Fine Art Tip

Blend the values together slightly to create a softer look to the rose. It's important to have both warm and cool temperatures and value changes to help create the form. The darkest darks in the rose will always be on the warmer side. Note: the turning shadow value/color where the petals fold back will always be a bit cooler than the darkest darks.

Artist Profile:
Elizabeth Robbins

"Paint what you love, paint what you are connected to. When you do this, paintings take on an emotional quality that speaks to the viewer."

—*Elizabeth Robbins*

Elizabeth Robbins inherited her love of flowers from her grandmother at a young age. Once she began painting as a young adult, flowers were her natural choice of subject.

Ironically, as her love of painting flowers grew, so did her priority to her children. Like many women, Elizabeth put her art career on hold and enjoyed painting as an occasional hobby. With her children now grown, she enjoys a flourishing full-time art career.

Elizabeth has earned signature status among important art organizations such as Oil Painters of America and the National Oil & Acrylic Painters' Society, and is a Master Signature member of American Women Artists.

Elizabeth is also an avid gardener. Her cottage garden is personal and embracing, informal yet traditional, much like her paintings. Her still-life paintings capture the essence of the bloom and almost its fragrance. I always look forward to seeing her latest creation, which she frequently posts on Facebook. I also enjoy spending time with Liz when I visit Utah.

elizabethrobbinsart.com

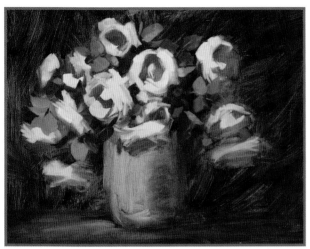

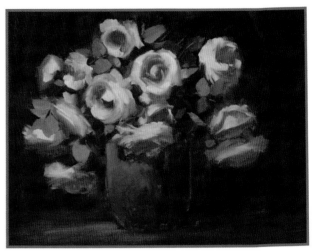

4 Develop Light and Shadow

Using a mixture of Titanium White, Cadmium Red and Cadmium Yellow Pale (very light creamy white), lay in the mixture in the light areas in a very simple pattern, using a no. 14 flat. Don't get caught up in detail. Do not use any medium or thinner at this point. Make the shadow areas thin and the light areas thicker and more opaque. Notice that some of the areas have more yellow and some areas have a bit more red. The purpose of this step is to create two values, light and shadow. Continuing with the no. 14 flat, add the leaves by mixing Viridian and Cadmium Yellow Deep for the lighter leaves and Viridian and Transparent Red Oxide for the darker leaves.

5 Soften the Edges

It's time to soften the hard edges in the roses and background by taking a clean no. 14 flat and blending the edges of the roses into the background. Blend some of the background and leaves into the roses, making some areas of the roses more greenish. Add light and shadow to the vase with a mixture of Viridian and Yellow Ochre Pale for the light value and Viridian and Transparent Red Oxide for the shadow area.

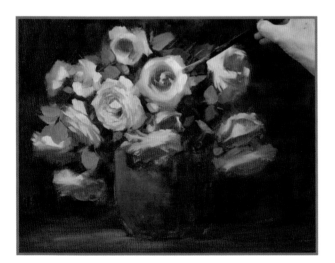

6 Create the Petals

This is when the magic happens. Using a no. 12 flat, blend the light mixture into the shadow mixture. This will create some different values and temperature changes within the roses. Next, mix two shadow colors. The first is Cadmium Red plus a little Alizarin Crimson. For the second shadow color, add French Ultramarine Blue and Titanium White to the warm red mix to create a warm gray-violet.

To help create form on the petal, take the no. 12 flat filled with the light mixture and place it going in the opposite way the petal grows. Once you have placed the light on in the opposite way, take a clean brush and pull the paint in the direction that the petal grows. This creates the illusion that the petal is curving and folding. Soften the light mixture into the shadow and add the warmer shadow color and the cooler shadow color, keeping some of the original Alizarin Crimson showing through.

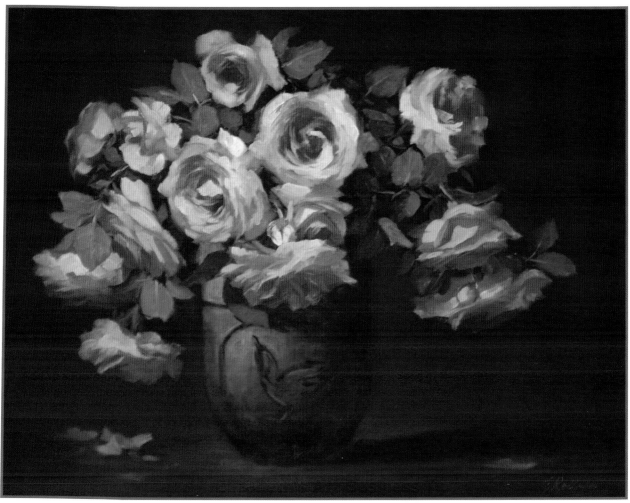

7 Add the Finishing Touches

At this point all the roses have temperature changes, lost and found edges and strong contrast in the focal point. Work the leaves by softening edges that you don't want to show and sharpened edges where you want the viewer to look. Using a no. 28 flat, I repainted the background with a mixture of Ivory Black, Yellow Ochre Pale and a touch of Alizarin Crimson. Finish up by adding more light and detailing to the vase and some petals on the table.

Song of the Roses
Elizabeth Robbins
Oil on linen
16" × 20" (41cm × 51cm)

Elizabeth's Art Business Tip

Don't scrimp on a frame. A good frame will make an average painting look better. A rule of thumb is to spend at least 10 percent of the value of the painting on a frame, so a $3,000 painting should get a $300 frame.

Painting an Outdoor Floral

This demo will help in simplifying a difficult and complex subject that has a thousand shapes. Editing is extremely important in painting. Shapes are all we have to navigate our visual life, so we are experts in deciphering shapes without even knowing it. The painting is ordered, with a background, middle ground and foreground. Each area with similar values groups together to form masses with unique shapes. As you arrange these elements in a dynamic way, focusing on a few shapes with specific recognizable silhouettes, the viewer's brain kicks in and says *I am looking at a beautiful bouquet of flowers*. This is the process of painting and being an illusionist with shapes and color on a two-dimensional surface.

MATERIALS

Support
20" × 16" (51cm × 41cm) canvas

Oil Paints
Alizarin Crimson, Burnt Sienna, Cadmium Red, Cadmium Yellow Medium, Payne's Gray, Quinacridone Violet, Sap Green, Ultramarine Blue, Van Dyke Brown, Yellow Ochre

Brushes
Nos. 4, 6, 8, 10 filberts

Other Supplies
Alkyd medium, glass palette, glass scraper, palette knives, paper towels

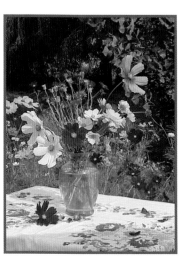

Reference Photo
Robert's plein air painting techniques are basically the same whether painting a landscape or a still life. He loves painting the effects of natural light and capturing the myriad colors in the outdoors.

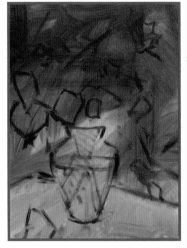

1 Start the Underpainting
Paint a medium value wash over the entire canvas using a no. 10 filbert and Payne's Gray, Burnt Sienna and Yellow Ochre in varied amounts. When dry, sketch on the major shapes with a no. 10 filbert and any dark color. The drawing will not show when finished, so the color of the drawing does not matter. Keep the contour simple and linked together in interesting arrangements. Keep the shapes unequal and your painting will be greatly improved.

Robert's Fine Art Tips

Robert uses these tips for focusing:

- If I hold my hand out and focus on it, the background will be out of focus. This is the way we see! Things only become in focus as we concentrate on them and choose to make them so. Thus we have much freedom in our choice to simplify shapes or to render them.

- Focus on a spot twenty feet behind the arrangement and the shapes will become simplified without having to squint.

- It is important to not get distracted by details. Instead of squinting, "look softly" by focusing behind the actual still life. This will simplify the masses.

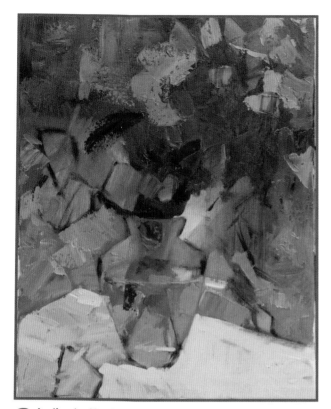

2 Indicate the Masses

Begin approximating the color of the masses. In your mind think of a stack of construction papers of varied colors and pick the color that best indicates the masses' hue, value and intensity. Attempt to see through the foreground details that scream for your attention and paint the stage before the main actors. Mix a large pile of paint on a glass palette and fill in the mass, comparing one area to another and making adjustments as you go. Continue to cover the canvas, comparing one color to another and filling in the shapes. There will be a progression of color changes within most masses so you will want to mix large amounts of paint to easily show the color shifts within the same value. Use as large of a brush as you are able to control and a palette knife to put a bit of surface texture within the appropriate masses.

Shapes Tip

Avoid using symbols for shapes (e.g., teepees, cotton balls, lollipops). Focus on and show the differences, not the similarities.

Artist Profile: Robert Moore

"Thank God every morning when you get up that you have something to do which must be done, whether you like it or not. Being forced to work, and forced to do your best, will breed in you temperance, self-control, diligence, strength of will, content and a hundred other virtues which the idle never know."
—Charles Kingsley

American impressionist Robert Moore possesses an authenticity that reflects his Idaho farm upbringing. With a deep appreciation for nature, Robert prefers plein-air painting on location to best express his subject. After receiving a full scholarship to attend the Art Center College of Design in California, Robert majored in illustration and graduated with honors.

I first met Robert during a plein-air painting event in Idaho, and we became fast friends. Later, I attended his popular five-day workshop where we focused on plein-air painting. Each day we painted outside on location, then in the evenings Robert would set up still-life arrangements. This was my introduction into still-life painting, which was a pivotal moment in my art career.

Tall and soft-spoken, Robert is a witty crowd pleaser. At plein air events, onlookers gather around as Robert paints from the back of his modified four-wheeler. Quite the showman, Robert wildly slings thick globs of oil paint with a palette knife in each hand and transforms a mess into a masterpiece. His bravado approach toward painting yields attention-grabbing textures and fascinating color patterns. And to top it off, Robert is color-blind!

rmoorefineart.com

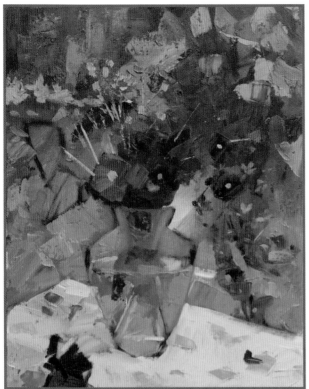

3 Create Smaller Shapes

Now focus on the smaller shapes in front of the simpler background masses. Once you determine the degree of contrast with the background, compare lights to lights, mediums to mediums and darks to darks. This way you won't be fooled by high contrasts in value or intensity. Remember to link the shapes together if they are similar colors and keep the shapes unequal. Begin to add some higher intensity colors such as Quinacridone Violet, Alizarin Crimson, Cadmium Yellow Medium and Cadmium Red. These colors will still need to be neutralized slightly.

Use as large of a brush as you are able to control and a palette knife to put a bit of surface texture within the appropriate masses.

4 Refine the Focal Point

Paint the center-of-interest flowers with the same process of simplification and order. Break the flowers into unequal shapes of "flower in light" and "flower in shadow" while comparing the colors. Don't paint the petals equal, but break them into unequal linked shapes, which will be more dynamic.

Palette Knife Tip

Use the palette knife to pick up and apply the leftover color onto the correct mass. This creates texture, and it saves you from having to remix the color if you make a shape adjustment later in the process.

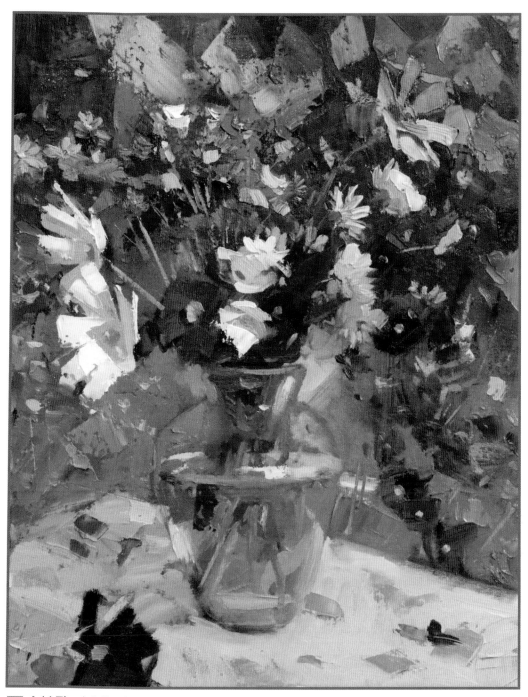

5 Add Final Adjustments

Finish the painting by designing the placement of additional details of flowers, stems and reflections in the vase. Each piece of contrast is like a magnet in the composition drawing the viewer's eye, so be aware and move the viewer's gaze around the entire painting. This is also the time to fix the ellipses on the glass. Notice the removal of the dark outlines on the top of the vase that were distracting and out of order. The reflected warm light on the main white flower is added to show form and to add interest to the painting.

Daisies
Robert Moore
Oil on canvas
20" × 16" (51cm × 41cm)

Lori's Art Business Tip

Art sales just don't happen. You have to create them, and you create art sales by having conversations. Have more conversations with potential clients and you'll most definitely have more sales. Robert Moore is good at this.

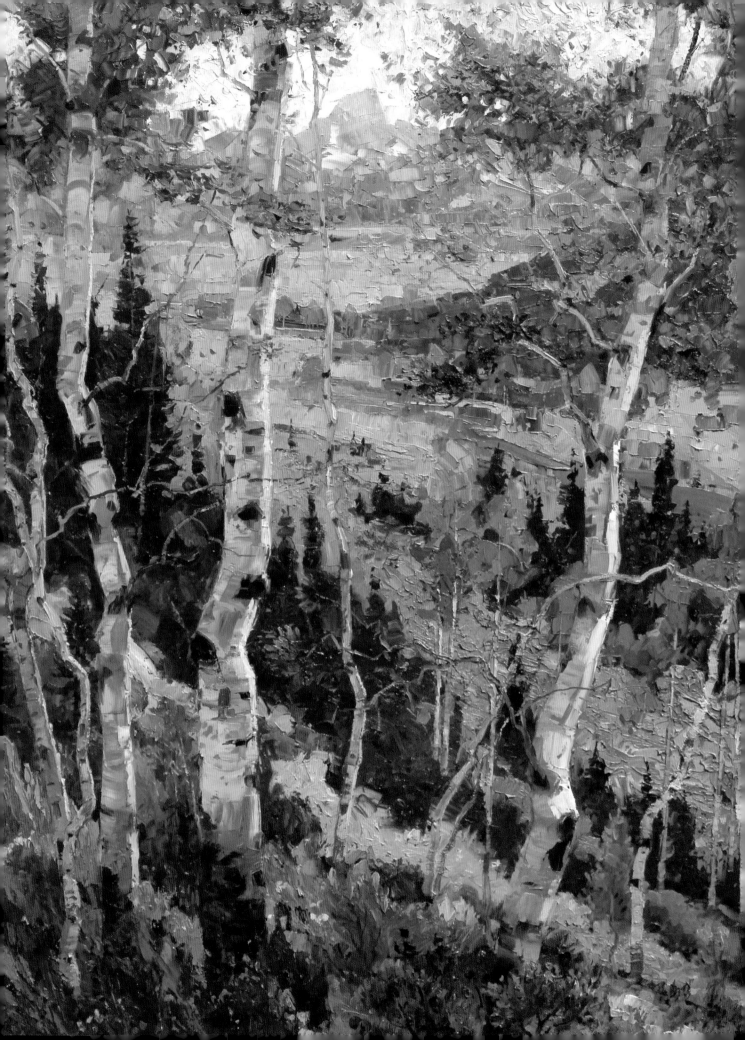

Plein Air and Studio Landscapes

The art of landscape painting is really quite incredible. Like a magician waving his magic wand, the artist translates the third dimension into a two-dimensional work of art. With just a few flicks of a brush, a lump of gray paint forms into a bank of clouds above a summer meadow. Dashes of color from a deft palette knife turn into bending grasses, and a yellow spot wondrously becomes a warm setting sun. Like windows to the imagination, landscape paintings lure the viewer into a world made of paint.

Generally, plein-air painting is direct painting that captures a moment in paint. Usually completed in one session, plein-air painting takes the artist from a controlled studio setting and into the unpredictable environment of Mother Nature. The scorching sun, blowing wind, blinding snow, annoying bugs and well-meaning spectators are just a few commonplace challenges of the seasoned outdoor painter.

Whether painting outside *en plein air* or inside the studio, the artist interprets the landscape and doesn't paint exactly what is seen. The landscape provides us with unlimited and sometimes overwhelming suggestions. Sketches and photographs might be used, but the artist must rely on taste and judgment to select, delete and compose a painting.

Within the following pages you will learn how some of today's finest painters transform dabs of colorful paint into beautiful, convincing landscape art. Follow the step-by-step demonstrations and peer into the thought process behind creating convincing landscapes!

Summer
Robert Moore
Oil on canvas
40" × 30" (102cm × 76cm)

Landscape Inspiration

A well-executed landscape painting transports the viewer to another time and space. Great landscape artists view their world with unique visions that inspire them to paint. Their goal is to create that same intense emotion in the person viewing the finished painting. Artists learn from each other. Use the following images to inspire your next landscape paintings.

Sausalito
Ken Auster
Oil on birch panel
16" × 20" (41cm × 51cm)

A Bright Spot
Kim Casebeer
Oil on linen
20" × 20" (51cm × 51cm)

Four Graces
Romona Youngquist
Oil on canvas
30" × 30" (76cm × 76cm)

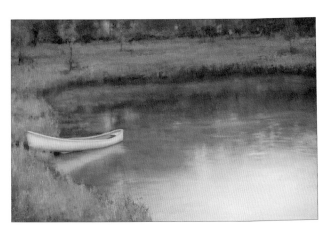

The Water's Edge
Lori McNee
Oil on linen
20" × 30" (51cm × 76cm)

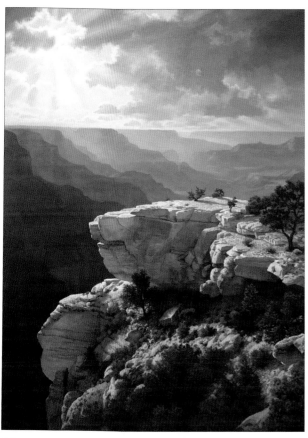

Afternoon Contemplation
John D. Cogan
Acrylic on museum wrap canvas
48" × 36" (122cm × 91cm)

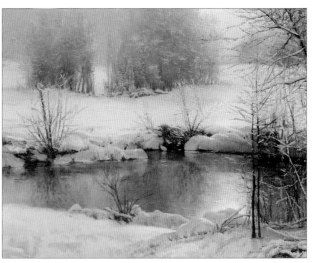

Winter Silence
Michael Godfrey
Oil on canvas
24" × 30" (61cm × 76cm)

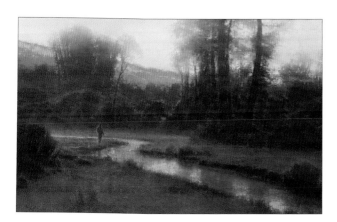

Spring Creek Twilight
Brent Cotton
Oil on linen
25" × 40" (64cm × 102cm)

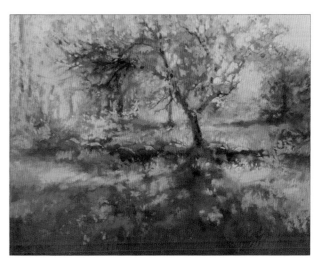

Verdant Burst
Christine Debrosky
Pastel on sanded paper
16" × 20" (41cm × 51cm)

Dramatic Low-Key Painting

I love to work in a series of paintings rather than on an individual piece at a time. For example, I might paint a particular landscape in a number of different keys or values, different seasons, the same format or even the same subject matter in differing palettes. Working like this helps me explore a subject or process to develop a unique and emotional composition. I am orchestrating and composing rather than just painting what I see.

Much like high or low notes on a piano, I can compose or "key" my painting with a chord of values. Here we will create a dramatic work by using a limited scale of low values to create a low-key painting.

MATERIALS

Support
24" × 24" (61cm × 61cm) linen on medium density fiberboard

Oil Paints
Cadmium Yellow Deep, Cerulean Blue, Cobalt Blue, Naples Yellow Light, Olive Green, Quinacridone Burnt Orange, Quinacridone Gold, Quinacridone Rose, Raw Sienna, Raw Umber Violet, Sap Green, Transparent Red Oxide, Ultramarine Blue, Utrecht White, Yellow Ochre

Brushes
¼-inch (6mm), ½-inch (13mm) and ¾-inch (19mm) flats

1-inch (25m) flat with very well-worn frayed ends

¼-inch (6mm) filbert

Sable brush

Other Supplies
Alkyd medium, cotton swabs, palette knives, paper towels

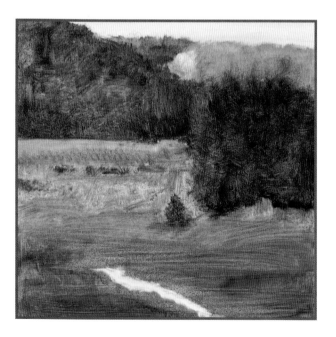

1 Create the Value Pattern Sketch

Using a 1-inch (25mm) flat, start with an initial value pattern sketch using the ground color. Pick the ground color by deciding the final overall hue, value, temperature and mood that you have in mind. With this low-key painting, I wanted a beautiful orange-red to show through the painting in the darks, giving the painting resonance and a quiet activity. Develop the value patterns very early on by wiping out the lights with a stiffer synthetic ½-inch (13mm) flat for lifting, along with cotton swabs and paper towels.

Use transparent pigments as much as possible and a little alkyd medium that will start tacking up quickly. Keep the value patterns between three to five shapes and values.

2 Establish the Darks

After the paint begins to tack up, go back in with the 1-inch (25mm) flat and re-establish the darks. Dark colors should almost always be the opposite temperature of the light. Use the transparent hues that will show through in areas of the mass, creating a vibration of color. This will simplify and connect the masses for a better composition. I love to start establishing my sky values and hue at this point as well. Establish the lightest lights and the "almost" darkest darks early on so you can judge the value ranges.

Shanna's Fine Art Tips

- Put the newly completed painting away for a day. Come back with a fresh eye and really look for gradations and depth of space.
- It is important to keep to three to five value masses for organization. If there are too many places of high contrast, the picture plane is flattened and the feeling of depth is destroyed.

Artist Profile: Shanna Kunz

Shanna's works reflect her spirit. An acclaimed contemporary landscape painter, Shanna is always looking to stretch herself and grow as a dedicated artist.

She is equally comfortable out in the field painting alongside some of today's most popular artists, or in the quiet of her Ogden, Utah, studio where she orchestrates her insightful works.

Shanna's paintings are a conscious play of mood, light and color that is rooted in her love of the diverse western American landscape. Shanna has a special fondness for trees. In fact, trees are seen in the majority of her paintings. She once told me, "Trees are my people."

For over a decade, Shanna and I have been close, personal friends. At art events, we are often mistaken for sisters, or even each other! I have shared many art shows and gallery exhibitions with Shanna, more than any other artist. Shanna and I have a supportive personal and professional relationship and always celebrate each other's successes.

Although she lives a state away, we stay connected. We often paint together and critique each other's work via Skype and keep in touch on Facebook.

shannakunz.com

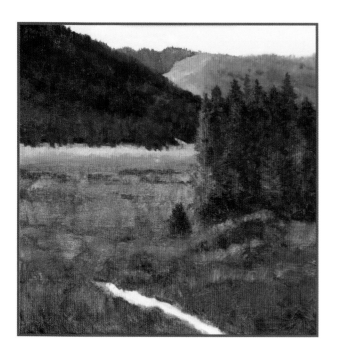

3 Develop the Local Color

At this stage, develop the local color with a palette knife and a stiff flat. The knife helps get more paint onto the canvas and creates nice edges. Key the painting by starting with the mid-value of the darkest mass. In each area of local color make slight temperature shifts, some cooler and some warmer. Keep some ground showing through.

Also establish the focal point of the painting. In this case, the turquoise of the backfield was what I fell in love with, as well as the strong evening light in the stream. Make a turquoise mixture of Cerulean Blue and a touch of Sap Green and Utrecht White, and lay it down more saturated and bolder in the beginning, knowing that you will temper later.

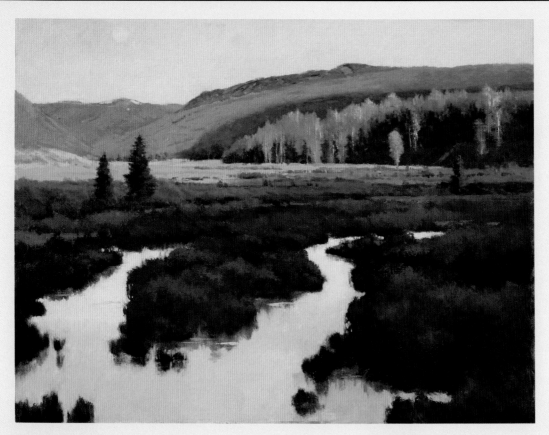

Creating Texture

Shanna Kunz followed the same techniques from her low-key demo to create *Moonrise*. However, notice how in this painting the mountains are bathed in light. Shanna enjoys skipping her paintbrush across the weave of the linen to create texture.

Moonrise
Shanna Kunz
Oil on linen
30" × 40" (76cm × 102cm)

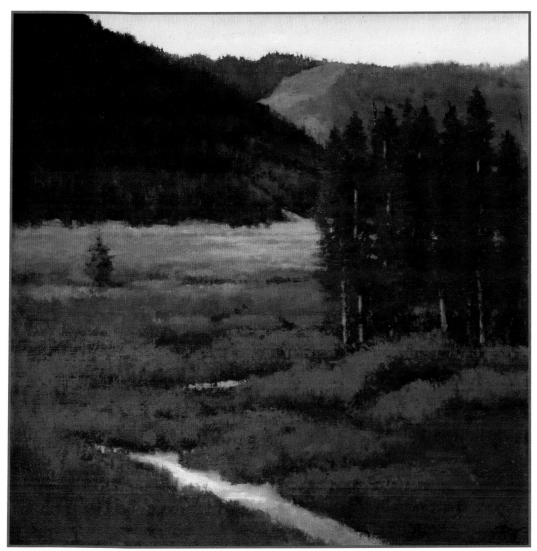

Evening Ride
Shanna Kunz
Oil on linen
24" × 24" (61cm × 61cm)

4 Add Glazes and Finishing Touches

With a sable brush, work the local color in the final masses to incorporate color temperature shifts, subtle value shifts and accents to develop the space and lead the eye through the painting. The center of interest remains bolder than the other masses.

Use thin transparent glazes (I use alkyd medium) to push and pull the masses and relationships. More detail goes in to create rhythm and direction.

At this point, do more observing than painting. Temper places that demand too much attention, put more glazes in places that need emphasis and add detail with a small bristle brush. A little goes a long way! The soft light on the pine trunks gives a beautiful stop to direct the viewer's eye to the sage blue field. I needed to illuminate the field more below the turquoise for the space to make sense. Put some lighter values in the largest shape of pines to give shape and dimension to the large mass and pull the eye up to the back mountain cliffs.

Notice how the dominant values stay in the low-key range with select contrast at the higher end. *Evening Ride* is moody and gives back the memory of my evening drive, just what I was looking for!

Shanna's Art Business Tip

Wherever you go, when anyone shows an interest in your work, get an email address by having them sign a guest book or have a database on your website. Add them to your newsletters, blog entries and special invitations. A person can sustain a career with collectors from the past. Give them the respect and attention they deserve for their support!

Developing a Focal Point

The first step in any painting is deciding what to paint. There is always an element in a vista or a photograph that makes you set up your easel. The artist must realize that human beings are only capable of seeing 5 percent of what they are looking at in focus. It is about the width of your thumb at arm's length. This is the hook or the focal point. Once you intellectually understand why you're creating this painting, which should be to glorify the focal point, then you can start your painting. You now have a purpose and a goal.

MATERIALS

Support
Prepared birch ply panel with light gray gesso or semi-gloss latex house paint

Oil Paints
Alizarin Crimson, Cadmium Red Light, Cadmium Yellow Medium, Carbon Black, Phthalo Blue, Titanium White, Ultramarine Blue

Brushes
Old hog hair bristle brushes of varying sizes

1- to 1½-inch (25mm–38mm) filberts

Rigger

No. 2 round

Nos. 4, 6 filberts

Nos. 4, 6, 8, 10 flats

Other Supplies
Freezer paper to cover palette, linseed oil, odorless mineral spirits, paper towels

1 Mark the Focal Point
Mark the area that will be in that 5 percent area; mark it in a comfortable place on the canvas, not in the corners or center. This is where all of the shapes in the painting will lead the viewer's eye, toward the pedestrians, who are the focal point. The basic block-in colors are Ultramarine Blue, Cadmium Yellow Medium, Alizarin Crimson, Carbon Black and Titanium White. Use the largest brush for the block-in to avoid adding detail in the foundation of the painting.

2 Fill in the Canvas

Start to fill in the canvas with brushstrokes, using a 1- to 1½-inch (25mm–38mm) square filbert. The larger the better to provide the necessary values, form and perspective needed to create a three-dimensional world on a two-dimensional surface. Use a rigger brush for spontaneous strokes and detail.

Create the form with at least three values to make the shapes and the source of light. It's very important to remember that you cannot be held hostage to what you are looking at. Use what you see as reference and paint what you know, not what you see.

3 Use the Spider Web Analogy

Treat the concept of brushstrokes like a spider web. Imagine the focal point being the center of the spider web. As the web gets farther from the center, its strands become farther apart and larger shapes appear between the web—larger brushstrokes and abstraction. As the strands of silk get closer to the center, they get closer together and tighter—smaller brushstrokes and more detailed. The whole concept leads your eye to the focal point.

Artist Profile: Ken Auster

A product of Southern California, Ken Auster built one of the world's most prominent silkscreen and T-shirt companies that created legendary surfing art. He received a B.F.A. degree and later made the transition from surf art to serious impressionism.

Ken's passion for plein-air oil painting is infused with a deft use of color and compositional organization. These attributes, along with his bold brushwork and his ability to paint anything, have led Ken's career to the forefront of American contemporary Impressionists.

Known for his cityscapes and figurative paintings, Ken is a popular workshop instructor. He is brilliant at breaking down complex scenes into easy-to-follow steps. A few years back, I had the opportunity to watch Ken in action at a Plein Air Convention. Quite the showman, Ken captivated the audience and me as he tackled an oversized cityscape painting with ease.

kenauster.com

End of the Line
Ken Auster
Oil on panel
16" × 20" (41cm × 51cm)

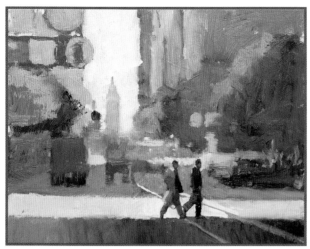

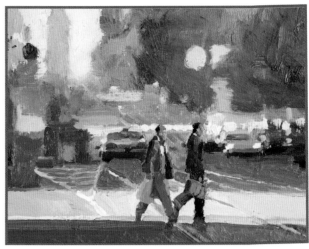

4 Don't Get Caught Up in the Detail

Use bigger brushes and keep yourself from putting in detail at this juncture of the painting process. Use smaller brushes closer to the focal point and larger brushes as you move away to the periphery. Mix puddles of color and lighten them with Titanium White to make lighter values of the same color. This will help set parts of the scene back into the distance.

5 Improve the Focal Point

Come back to the focal point and develop it to the point of almost finished. Use crisp edges and the darkest dark against the lightest light. The headlights and taillights are pure color. To create the headlights, add a tint of Cadmium Yellow Medium to the Titanium White for intensity. Use Cadmium Red Light straight from the tube to make the taillights glow.

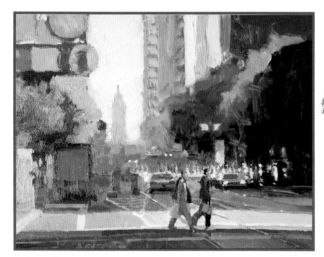

6 Refine Color and Edges

Add a color that doesn't appear anywhere else in the painting. This will now give you a spot in your painting that you cannot resist looking at.

The eye is always attracted to edges, so use the edges to guide the eye through the painting to the focal point. Your eye will follow crisp edges and dismiss soft edges.

Ken's Fine Art Tips

- Paint warmer colors closer to the foreground, cooler colors to the rear or in the distance.
- Paint more intense colors closer to the foreground and less intense colors in the distance.
- Remember, there is only one focal point in the painting. Like a good movie, there is one lead actor and several supporting actors.

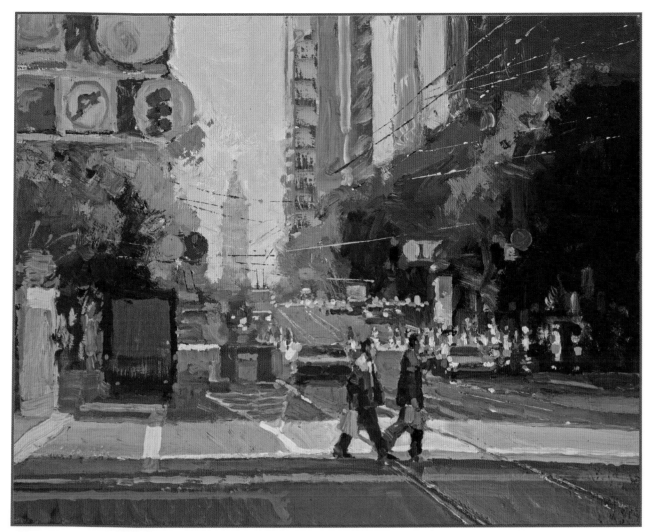

7 Add the Finishing Touches

Continue softening some edges and making other edges more crisp to guide the eye through the painting to the focal point. Look at your painting with a fresh eye, and manipulate the edges. Make sure that from all places in the painting you can easily get to the focal point with no jumping around. Remember, create one focal point and build the painting around it.

From Market to Market
Ken Auster
Oil on birch ply panel
16" × 20" (41cm × 51cm)

Ken's Art Business Tip

As in business, as in painting: think about it before you jump in with both feet.

OIL DEMONSTRATION • ROBERT MOORE

Painting Dynamic Aspen Trees

In this demo you will learn to simplify and design a composition from a complex subject. We will set the stage for the main players of the painting by simplifying the background masses, the foliage masses and the ground plane masses. We'll then paint the two aspen trees with special attention given to the individual characteristics of these particular trees. The color will be harmonious because of the light filtering through the canopy of leaves overhead, with only a couple notes of cool complementary colors.

MATERIALS

Support
36" × 24" (91cm × 61cm) canvas

Oil Paints
Alizarin Crimson, Burnt Sienna, Cadmium Orange, Cadmium Yellow Medium, Payne's Gray, Quinacridone Violet, Sap Green, Titanium White, Ultramarine Blue, Van Dyke Brown, Yellow Ochre

Brushes
Nos. 4, 6, 8 filberts

Other Supplies
3-inch (76mm) palette knife, alkyd medium, brush cleaner, glass palette, glass scraper, odorless mineral spirits, paper towels

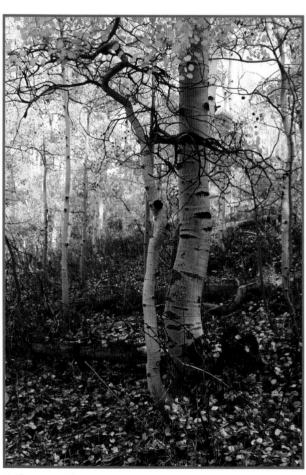

Reference Photo
Organizing chaos, Robert Moore paints "spectrums beyond his perception." He chooses scenes that highlight his impressionistic flair.

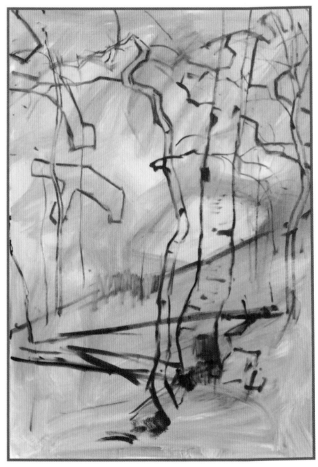

1 Sketch the Aspen
Sketch the major shapes of the aspen, ground, sky and foliage onto a canvas washed in with Yellow Ochre and Burnt Sienna thinned with mineral spirits. When drawing the shapes, focus on the differences and not the similarities (e.g., long vs. short or curved vs. straight).

60 Visit ArtistsNetwork.com/Fine-Art-Tips-Lori-McNee for FREE bonus materials.

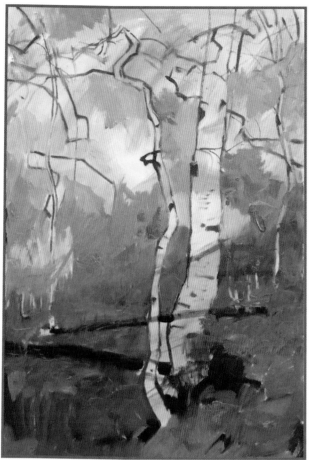

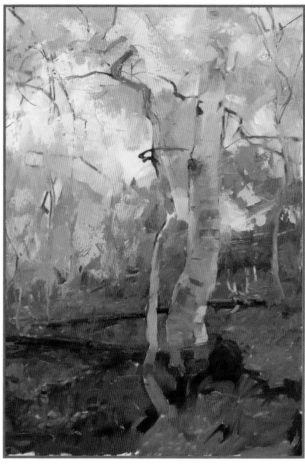

2 Fill in the Shapes

Begin to fill in the shapes with colors made with combinations of Cadmium Yellow Medium, Yellow Ochre, Burnt Sienna, Titanium White and a touch of Payne's Gray. Once you have established the right relationship, take the leftover paint on a palette knife and apply to the interior of the mass of the same color. This saves having to remix the color later in the process should you want to make small changes.

3 Focus on the Trunks

Approximate the color of the aspen trunk with Yellow Ochre, Burnt Sienna, Payne's Gray and Titanium White. Cover the entire trunk with the paint, and add the dark knots with Van Dyke Brown or any dark value neutral orange. Vary the value of the trunks to suggest the turning away from and the turning toward the secondary light source.

Robert's Fine Art Tip

When mixing colors, use a large glass palette with a lot of paint shifting from one color into another. Using a large quantity of paint will create chords of color and not just single notes. This will produce natural effects of color.

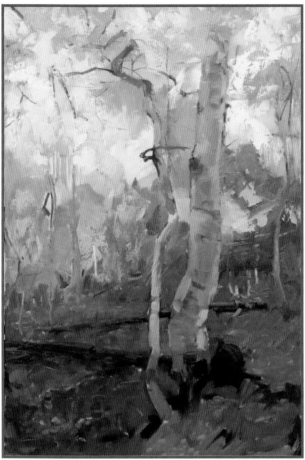

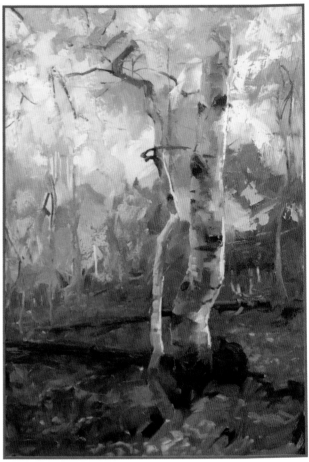

4 Paint in the Sky Holes
Mix the sky color so it is markedly lighter in value and cooler in hue, and cover the sky holes. Remember to make the holes good shapes. Try to avoid monotonous cotton ball shapes. Focus on the differences that make the shapes unique.

5 Detail the Trunks
Using mostly Titanium White with a touch of Cadmium Yellow Medium, Cadmium Orange and Van Dyke Brown, mix the trunk highlight color. Now apply it to the edge of the tree using a 3-inch (76mm) palette knife and softening with a no. 6 or 8 filbert. Use a good amount of paint so it doesn't mix with the paint on the trunk.

Robert's Fine Art Tip

As the limbs and branches go farther from the trunk, lighten the value to give the illusion of light enveloping the smaller forms.

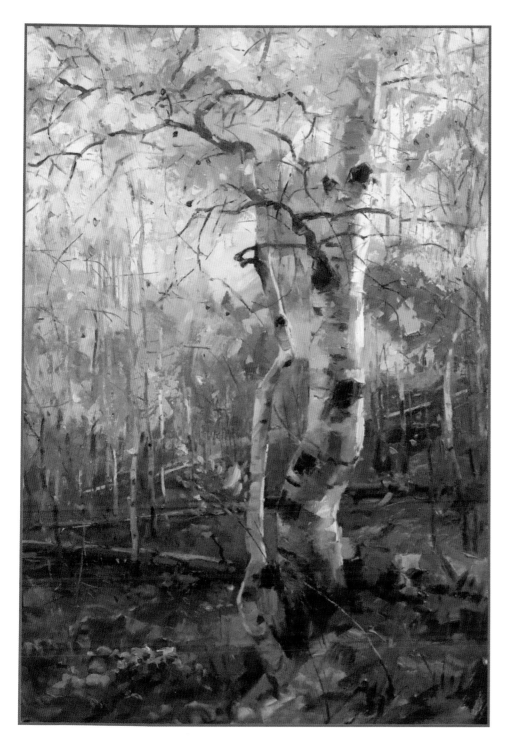

6 Add the Finishing Touches

Add the reflective light on the trunk to give the sense of roundness and volume. Soften the edges of portions of the masses by scraping with a palette knife. Finish by adding some detail of limbs and branches and a few spots of leaves placed to move the eye of the viewer around the composition. Break the continuous line of the limbs to avoid the feeling that they are "cut out" and not part of the environment. Finally, to give some relief to the warm tone of the painting, add a few notes of cool flowers in the foreground with a mix of Ultramarine Blue, Alizarin Crimson and a small amount of Yellow Ochre to neutralize the color.

Friends
Robert Moore
Oil on canvas
36" × 24" (91cm × 61cm)

Robert's Art Business Tip

A professional artist is one who follows art as a means of livelihood or for gain.

Painting Sparkling Light on Water

This misty and moody early morning scene of a drift boat and fly fisherman is the type of subject that really gets me excited. My reference for this painting was just a poor-quality cell phone photo my wife took of me, my dad and my brother in my drift boat on the Bitterroot River in western Montana, my home river. I liked the overall composition but wanted to change the color and lighting to make it more dramatic. I also changed the pose of the figure out front and gave the impression of a line of trees in the background that the light was shining through.

MATERIALS

Support
18" × 24" (46cm × 61cm) alkyd primed linen mounted to ½-inch (13mm) Gator board

Oil Paints
Cadmium Orange, Cadmium Red Light, Cadmium Yellow, Cobalt Blue, Titanium White, Transparent Oxide Brown, Viridian, Yellow Ochre

Brushes
Nos. 2, 4, 6, 14 filberts

Other Supplies
Alkyd medium, citrus thinner, latex gloves, palette knives, paper towels, solvent

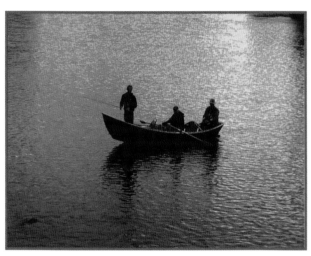

Reference Photo
The simplicity of the boat and water without much in the way of background or detail inspired me.

Brent's Fine Art Tips

To create the illusion of intense light:
- The edges have to be soft and lost in spots getting progressively harder as they move away from the light. This will give the illusion of intense light.
- The linen has a fair amount of tooth and the knife really picks up the texture when paint is dragged across it lightly. This does a great job of simulating light sparkling on water.

1 Start the Drawing and Mid-Values

With a no. 14 filbert bristle brush, begin scumbling in a background color with opaque oil paint (Yellow Ochre, Cadmium Red Light and a little Viridian) thinned a bit with alkyd medium. Apply it thinly over all the linen, aiming for a middle value that will work well with the lights and darks that will come later. Let this underlying color dry for a couple of days before painting the boat and figures over the top.

Once dry, draw in the main subject with a soft synthetic no. 4 filbert and paint that has been thinned with alkyd medium to improve the flow and gloss. The dry background makes it easy to wipe off any mistakes in the drawing.

2 Fill in the Drawing

Now, begin to fill in the drawing outline, working from darker to lighter where the boat will be backlit. The boat and figures are made up of Transparent Oxide Brown, Cadmium Red Light, Yellow Ochre and a small amount of Cobalt Blue. For this step use nos. 2, 4 and 6 synthetic filberts to fill in the outline, but be careful not to obliterate the drawing.

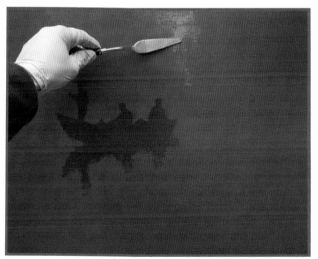

3 Add the Light

Next, move to the streak of light that appears to be coming through the trees and reflecting onto the water. Establish the darkest darks and lightest lights early on so you can judge all the other values based on those two extremes. Use Cadmium Orange, Cadmium Yellow, and Titanium White applied with a palette knife. Lay the paint on thickly, impasto in spots, and in other areas just drag the knife with very little paint. Let the knife hit the tops of the weave, which gives it a sparkly or grainy effect. For this step and all others that require a palette knife, I used a Holbein hand-forged steel palette knife and my trusty finger or thumb "brush" to soften.

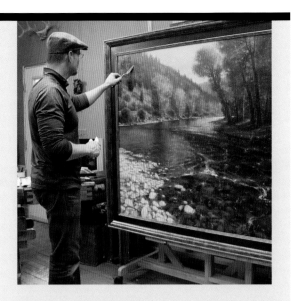

Artist Profile: Brent Cotton

"No man enters the same river twice, for the river has changed and so has the man."
—Heraclitus

Brent Cotton is a man who is inspired and haunted by water. He grew up on his family's cattle ranch in Idaho, where his love of the rivers and the outdoors led him to pursue art. After years of refining his artistic direction by working with world-renowned mentors such as Howard Terpning, Brent's paintings have evolved into elegant, poetic landscapes. "God's glory" and the fleeting effects of light on the landscape inspire Brent. His works bring a sense of nostalgia and peace to the viewer.

The first time I saw a Brent painting was while attending the Arts for the Parks national exhibition in 2003. It's rare that a single painting stays etched in my mind, but *Evensong* did just that. I still remember the silhouette of the lone canoe gliding along sepia-toned, placid waters, leaving only a sliver of shimmering golden reflections in its wake—truly breathtaking.

Recently, I visited Brent and his family at his studio in the awe-inspiring Bitterroot Valley of Montana. Brent reminded me that he and I first met back in the early 1990s during a wildlife painting workshop with Guy Coheleach! What a small world.

cottonfinearts.com

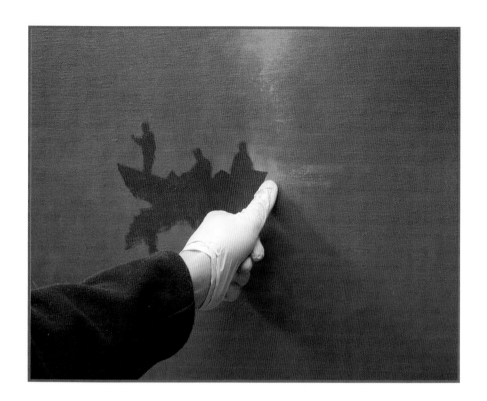

4 Blend the Light

Blend and soften the edges where the boat meets the water and is strongly backlit. I wear gloves when I paint because I'm always using my thumb or fingers to blend and push the paint around.

Use a palette knife and continue to refine the drawing with color that is a very close match to the background color. Lay this on thinly with the knife and drag across the background, painting the negative shapes around the boat and figures and creating a variety of edges where they meet. Continue to soften and blend with your trusty finger and thumb brush.

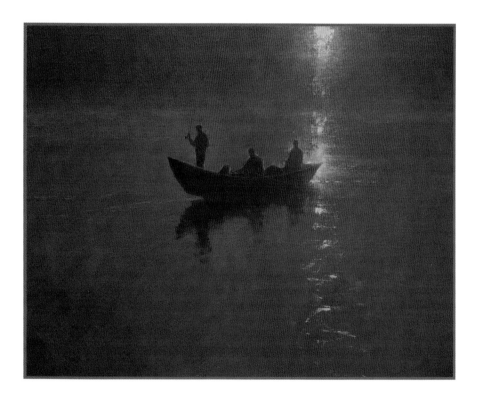

5 Intensify the Highlights

Refine the drawing on the boat and figures and increase the contrast by putting in intense highlights. In this step, edges and values are important to get the feeling of backlighting. Work from the end of the boat, up to the standing figure. Refine his form and put a fly rod in his outstretched arm. If you look closely, you can see the fly line that is being cast by the fisherman. For this, drag the palette knife very carefully in one pass and vary it along the way to simulate being hit by the light. Put the oar in the same way.

Visit ArtistsNetwork.com/Fine-Art-Tips-Lori-McNee for FREE bonus materials.

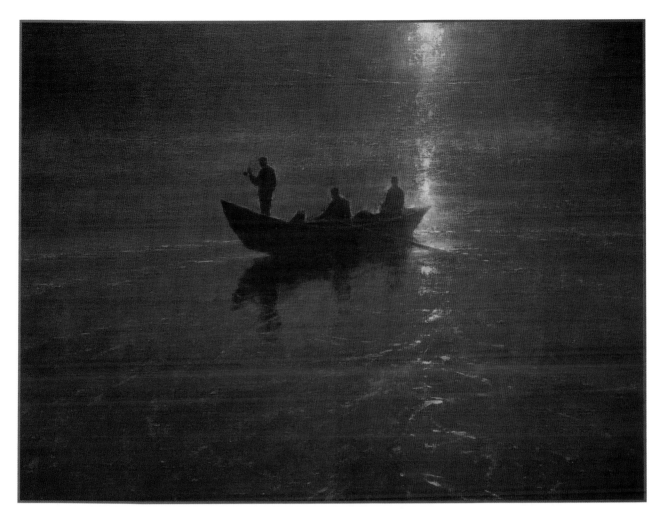

6 Indicate Motion and Reflected Light

As you can see, I also brought more light down into the water to give the impression of movement and liquidity. Put a few ripple marks in the water to indicate motion and reflected light. Create the ripples with the palette knife, both in a dragging fashion and applying more impasto in spots.

Last, glaze some darker color into the corners of the painting with paint thinned with alkyd medium. This has increased the "pop" of the finished piece.

Drifting in Time
Brent Cotton
Oil on linen
18" × 24" (46cm × 61cm)

Brent's Art Business Tip

A professional artist is a person who derives his living solely from art, but also someone who takes his talent and skill seriously and works hard at developing his own style and voice. A professional artist consistently produces quality works and moves the viewer in some way. An art degree doesn't make a professional. I know plenty of artists who are doing very well and have no degrees whatsoever. They've just put in the time and made it happen through sheer will and determination.

Painting a Snowy Landscape

I use plein-air sketches and photographic references to compose my studio work. The sketches are best for remembering observed color of a particular locale. Photographic references are good for details.

I like the coloration of this early morning scene, but compositionally there is no way for the viewer to "move" back into the space visually. I plan to remedy that by opening up the background. When working with source material, do not be constrained by what you see, but use your artistic license to create your own unique work.

This morning scene has a very warm yellow sun that causes the shadowing on the snow to skew more toward purple. The sky color also reflects on the snow. As a day progresses, the colors will change. It is important to decide beforehand what time of day and what the quality of light is. Is it an overcast day, partly cloudy or is there direct sun? These details will inform you in your palette choices.

It is my goal that you learn a few tips on how and what to look for when painting a scene that features snow.

MATERIALS

Support
12" × 16" (30cm × 41cm) panel

Oil Paints
Cadmium Red, Cadmium Yellow Light, Cadmium Yellow Medium, Cobalt Blue, Ivory Black, Naples Yellow, Permanent Rose, Phthalo Green, Titanium White, Ultramarine Blue, Van Dyke Brown, Yellow Ochre

Brushes
Rounds for sketching

Variety of flats for bold strokes and linework

Other Supplies
Alkyd medium, turpentine

Reference Photo
The photo reference for this painting was taken early in the morning just after a fresh snowfall.

1 Start With the Rule of Thirds
Start with a panel toned with a mixture of turpentine and Van Dyke Brown. It is easier to judge values with a toned surface. This warmed surface serves to counteract the tendency to paint a snow scene too cool.

For the composition, use the rule of thirds. It looks like a tic-tac-toe board. Aligning areas of interest with these lines creates a more interesting composition and helps you avoid putting compositional elements in the center of the panel.

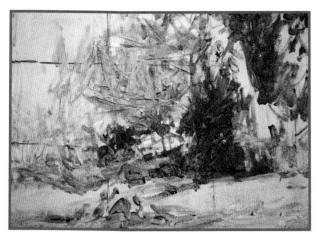

2 Add the Darkest Values
Next, with a no. 8 or 10 flat, establish the darkest values and design a big mass of trees in the dominant area of interest.

3 Start the Block-In
The initial block-in is the most important stage of the painting. It is the time to establish the values and compositional elements in an abstract manner. With a flat, establish the basic shapes that will dominate the composition. After the block-in you can study the shapes and decide if the painting is worth finishing.

Michael's Fine Art Tips

- Light: The way an artist controls light in a painting is one of the most critical elements in the painting process. It establishes the mood, look and feel of a painting.
- Design: The design is how you arrange the key elements to create an interesting composition rather than copying your source material literally.
- Values: The way you control darks and lights helps create a dynamic composition and aids the viewer in understanding the work.

Artist Profile: Michael Godfrey

Critics have described Michael Godfrey's exquisite painting style as a blend of Impressionism from George Inness with the added drama and Luminism of Albert Bierstadt.

Born in Germany and reared in North Carolina, Michael earned a B.F.A. and began his painting career in watercolors and oils. Today, Michael spends hours in the field, sketching and photographing in order to prepare for his next well-planned painting.

Michael believes that landscape artists must have knowledge in geology, chemistry, physics and architecture in order to understand the world they are portraying in paint.

He hopes his paintings help people notice the special moments that happen every day, especially the drama when light first splashes across a scene. His desire is to reflect the wonder of God's creation in his paintings.

Michael and I have been Facebook friends for many years. His splendid paintings beautify my Facebook feed. It was special to finally meet Michael in real life at a Plein Air Convention. His refined demeanor and sophistication are truly reflected in his work.

michaelgodfrey.com

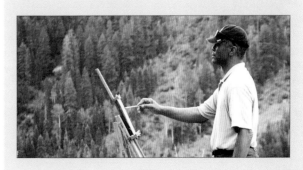

4 Distinguish the Masses

The closer tree mass is a mixture of Yellow Ochre, Phthalo Green and Van Dyke Brown. The background tree mass is a mixture of Naples Yellow, Titanium White, Permanent Rose and Van Dyke Brown. It is important to keep the background grayed out. At the bottom of the background tree mass, add Cobalt Blue.

Snow is not white, but reflects to some degree all the colors in the immediate environment. The color of the sky will dictate the overall coloration of the snow. The sky mixture is a combination of Cobalt Blue, Phthalo Green, Titanium White and a little Van Dyke Brown to dull the mix. Add some random dark strokes to the background to indicate branch masses.

5 Block in the Snow

After setting up the structure for the painting it is time to block in the snowfall. In Maryland we typically have heavy wet snows that cling to everything. This is the characteristic of snow that most attracts me. Use a mixture of Cobalt Blue, Permanent Rose, Van Dyke Brown and Titanium White. This dulled mixture will make some areas of snow visually recede from the viewer. At this stage, focus on the reflected light on the snow and shadowed areas. Add a little Phthalo Green to the mixture for the snow that is closest to the viewer so that it will come forward.

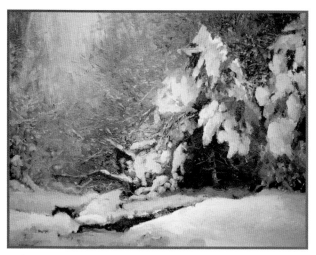

6 Model the Snow

It is essential that the snow appears to have weight. This is accomplished by modeling. Clumps of snow will have areas that are in shadow, areas that catch direct sun and areas of reflected light. The areas of reflected light tend to appear warmer in tone than shadowed areas.

7 Create Believable Branches

Add more contrast to the branches and tangles of the background and continue to model the snow. Paint the areas that are to receive direct sunlight. I use a mixture of Titanium White, Naples Yellow, with a touch of Permanent Rose.

Add more Phthalo Green to the snow in the foreground areas and add bits of snow to the branches throughout the painting.

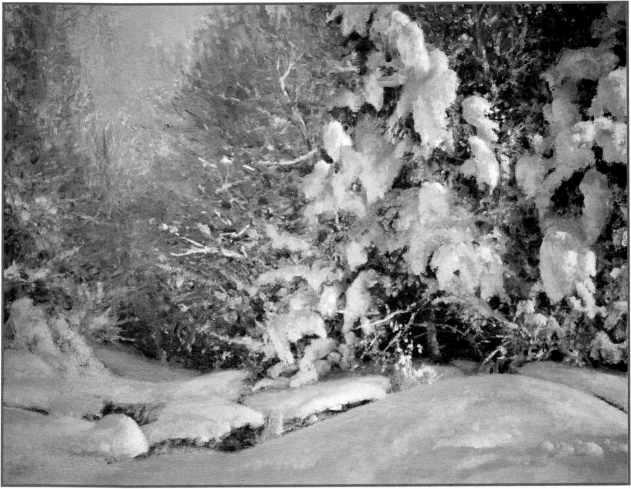

Winter Light
Michael Godfrey
Oil on panel
12" × 16" (30cm × 41cm)

8 Add the Finishing Touches

Use a little Ivory Black with Van Dyke Brown for the shadowing under the foreground trees. The planes of the snow that are parallel to the sky will reflect the color of the sky. As a last step, introduce the sky colors on the snow areas and intensify the shadowing on the snow in the foreground trees.

Michael's Fine Art Tips

- Avoiding black pigment is good advice for beginners as you have to be careful with its use. However, at certain times you need a good strong dark value, and only black will do. Always cut black with Van Dyke Brown, Phthalo Green or Permanent Rose, depending on the need.
- An artist's palette choices are very personal. You will fall in love with some color combinations and reject others. Purchase a basic palette and slowly experiment with others. There are several paths to arrive at a particular color through color mixing.
- A variety of brushes are essential to creating interesting surfaces. The key is to get very familiar with these tools. Buy the best brushes you can afford.

Reflected Light

This detail illustrates the direct light and areas of reflected light. The top of the snow reflects the sky, while the bottom, which tends to be warmer, reflects the light bouncing off the snow that lies on the ground.

Painting Lively Clouds

Clouds are one of the most fun subjects to paint. The clouds in the sky often tell a story of what the weather is doing. Puffy cumulus clouds can be found on a sunny day. Cumulonimbus clouds indicate a storm is brewing. Wispy cirrus clouds often form during clear, quiet days and evenings.

The open range of the Kansas Flint Hills where I live is perfect for painting a big sky. This demo has a trickier composition with a rainstorm brewing over mountains. Although rainstorm clouds look dark and heavy, notice how much lighter the darks of the clouds are in relationship with the darks of the ground plane. Remember, even dark clouds need to look as though they float!

MATERIALS

Support
30" × 40" (76cm × 102cm) medium-tooth primed canvas or linen mounted to Gator board

Oil Paints
Alizarin Permanent, Asphaltum, Burnt Sienna, Cadmium Red Light, Cadmium Yellow Deep, Cadmium Yellow Light, Cobalt Blue, Permanent Green Light, Titanium White, Transparent Orange, Ultramarine Blue, Viridian, Yellow Ochre

Brushes
Nos. 4, 6, 8, 10, 12 brights

Nos. 4, 6, 8, 10, 12 flats

Talcon bristle blend brush

Other Supplies
2½-inch (64mm) palette knife, cotton rag, odorless mineral spirits

Kim's Fine Art Tip

When purchasing design markers, choose the kind with a fine tip on one end for lines and a broad tip on the other end for filling in masses. Get three to five markers in values of cool gray.

1 Start Every Painting With a Plan
Before beginning a studio landscape painting, make a clear plan. Lay out your composition using line, shape and value. These thumbnails can be done in graphite, monochromatic paint washes or design markers.

It is also ideal to start with a color sketch, referred to as a plein-air painting. A plein-air piece is useful to remember the moment—was it warm, cool, windy, sunny?

2 Begin the Painting With a Wash

Tone the canvas with a light wash in a warm neutral such as Burnt Sienna. Loosely draw the composition on your canvas using Burnt Sienna and Ultramarine Blue thinned with odorless mineral spirits. A sketch in thin paint can be easily painted over and won't muddy like graphite. Establishing the darker value masses with the Burnt Sienna and Ultramarine Blue wash helps establish the horizon line early in the painting. Use nos. 10 and 12 flats for this step.

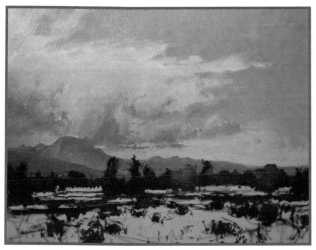

3 Work Big to Small

Use a no. 12 or 10 bright to block in the large masses first and work over the entire painting. On a painting this size (30" × 40" [76cm × 102cm]), start your block-in with the center of interest, in this case the sky and where the sky meets the mountain's edge. It's helpful to block the mountains in with the sky. Keep in mind that clouds move with the wind's direction. Start with the intense colors and middle and dark values. It's much easier to tone down color in subsequent passes than to brighten grays later.

Artist Profile: Kim Casebeer

"It's as much of what's not in the painting as what is."

—Kim Casebeer

Born to a fourth-generation farming family of Kansas, Kim Casebeer believes the wide-open ranchland and simple landscape of the Midwest helped shape her sense of design to understand what's important in a composition.

After earning a B.F.A., Kim worked as a graphic designer and art director. Dedicated to her passion, Kim would spend evenings and weekends painting until she was able to make the leap into a full-time art career in 2002.

Since then, Kim's work has been featured in prominent art magazines, museums, and salon shows, including the C.M. Russell Auction. Kim is a Master Signature Member of American Women Artists and a Signature Member of the Oil Painters of America. She has earned the respect of museums, collectors and, more importantly, her peers.

kimcasebeer.com

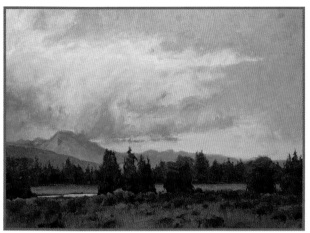

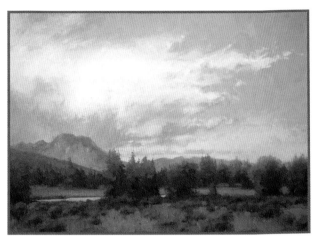

4 Block In the Foreground

After blocking in the sky and the middle ground, it's time to block in the foreground's large masses. Paint the dark and middle values of the trees and ground plane with paint just thick enough to cover the wash. Variety in value and temperature of color will be needed in the foreground grasses, but begin with dominant warmer colors that will peek through when you add cooler grasses. Start with the dark and medium values of the dominant cool greens when painting the sage.

5 Break Down the Large Masses

Introduce lighter values and some dark accents within each cloud mass to turn the form. Use a no. 6 or 8 bright or flat. To keep the composition strong, these value changes should remain close within the large shapes. A transition of lighter values will show where sunlight hits the cloud. The lighter values within the shadows of the clouds need to be darker than the values in the sunlit parts of the clouds.

There is a lot of atmosphere between you and those clouds, and softening the edges is necessary in order to achieve this effect. Use a dry brush to soften edges. Show variety between thin wispy clouds and dense clouds. The rain in the distance that's falling by the mountain needs to be painted now so that the closer layers of clouds can be developed in front.

6 Add Texture

Paint thin to thick, and remember that texture is an important part of a complete painting. Thicker paint over the earlier, thinner layers provides variety. Use a palette knife to paint the thick layers. The knife can be effective in subjects such as clouds, where spontaneity is important. Notice the variety of light colors of the same value: greens, violets, yellows and oranges. These light values blend visually.

After the knife work is complete, use a no. 10 flat synthetic bristle blend brush to smooth the texture until it's less distracting. Hold the dry bristle brush on its side against the painting and gently blend with a light touch.

Kim's Fine Art Tips

- Mentally divide your painting into three parts: background, middle ground and foreground. The middle ground has to closely relate to the sky in value and color.
- Use a dry bristle brush to soften edges. To keep the brush clean and dry, wipe it on a cotton rag held between your fingers instead of using odorless mineral spirits to clean.
- A large painting cannot be completed in a few days. On the first day, complete your thumbnails and color sketches, tone your canvas and draw your composition. Wait to start the block-in on day two. By day three, you should be able to start softening edges before the paint dries.
- Step back and look throughout the process of painting. Does the center of interest still stand out?

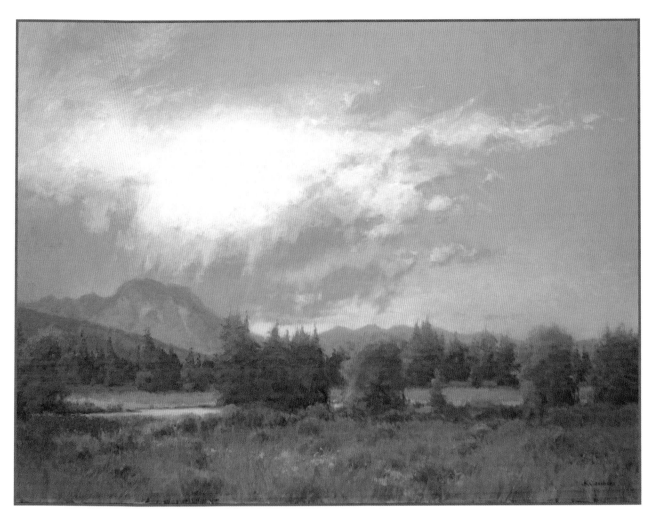

7 Fine-Tune the Painting

Exaggerate the rain movement with lighter wisps from the large cloud to the mountain. Add some lighter and darker values to the cloud, highlights to the trees and grasses, and warmer, more intense color where the sky and mountain meet to increase drama.

Scumble darker color over the middle clouds to bring the values closer and prevent them from distracting your eye from the center of interest.

Warm, intense color added to the river will reflect the warmth in the sky. Adding middle-value greens to the ground plane acts as a transition between the sage and the ochre and brown grasses.

Finally, a few well-placed flowers in the foreground create added interest.

Summer Renewal
Kim Casebeer
Oil on linen
30" × 40" (76cm × 102cm)

Painting a Large Landscape

Want to paint a big painting? Tackle the job using the following manageable steps: First, make sure to have a scene that excites you because you'll be living with this canvas for a while. Before you touch a brush ask yourself, *What do I want to say or feel with this piece?* With *Lavender Sunset*, I wanted the viewer to lose herself into the late afternoon at an old-fashioned lavender farm. You can almost smell the fragrance and warmth of the summer day as it drifts toward evening.

MATERIALS

Support

60" × 60" (152cm × 152cm) stretched canvas

Paints

Alizarin Crimson, Cadmium Red Light, Cadmium Yellow Light, Titanium White, Transparent Earth Red, Ultramarine Blue

Brushes

1- to 2-inch (25mm–51mm) hardware brushes (several)

Nos. 8, 10, 12 flats

Other Supplies

Alkyd medium, light- to medium-grade sandpaper, odorless mineral spirits, palette knives, rags or paper towels

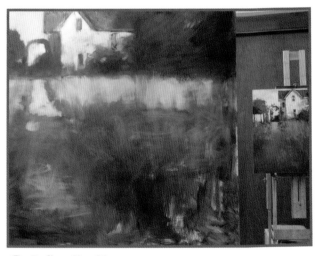

1 Start the Composition

Work out your scene first with plein-air studies, photos and sketches, and get your composition planned. Then, divide your canvas into a simplified golden section of thirds like a tic-tac-toe board (refer to Michael Godfrey's demo in this chapter for more on this technique). Use this to help you decide upon the horizon line and the four points of interest where the lines intersect, and then determine the focal point (refer to Ken Auster's demo in this chapter for more on this technique). I often mark an X in the center of the canvas to remind me where the middle is.

Using a 2-inch (51mm) hardware brush, draw in the composition. Then, step back. Painting large means walking miles backwards to see what's going on.

2 Define the Shapes

With my small study as a road map, I work from the focal point out to define the shapes. Lay in rich darks in the dominant mass, and get some contrast by wiping out the light positive shapes. Remember to keep it simple and abstract at this point.

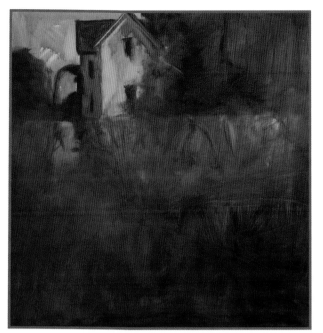

3 Add the Wash

Create a simple yet abstract design for the underpainting. Mix a dark purple wash of Ultramarine Blue, Alizarin Crimson and a little Transparent Earth Red and mass in the shapes with a 2-inch (51mm) hardware brush.

Work from the focal point out. Keep this to abstract forms, and squint down to see the masses and values. Cover the canvas with this medium-value wash.

Romona's Fine Art Tips

- Take a picture of your painting in progress and transfer it to your iPad or computer. This helps to give a new perspective to see what is and isn't working.
- Buy flat brushes. They will eventually turn into filberts.
- Use big brushes until the end, except for wiping out the delicate light areas. Poking at the painting can kill it quickly.
- When mixing, try to add all the colors you'll be using to your palette. This will make for a harmonious painting.
- Mistakes in small paintings can sometimes be overlooked, but small mistakes in big paintings are magnified.
- A limited palette makes for a simpler and harmonious painting.

Artist Profile:
Romona Youngquist

From the lush Red Hills of Dundee, Oregon, Romona Youngquist finds inspiration in the flourishing vineyards and breathtaking landscapes near her studio. With nature as her classroom and the great masters as her teachers, Romona has risen to the top as an acclaimed landscape painter. Her contemplative works are bathed in light and atmosphere that harken back to days gone by.

When executing a painting, Romona considers the canvas a "war zone." Her weapons of choice are sandpaper, ends of brushes, rags and any unconventional tool she can employ. The canvas endures wiping out, scraping, brushwork, fierce palette knife work and then glazing before it surrenders to Romona's vision.

Romona and I are kindred spirits, sharing a love of nature and animals. Surrounded by her pets, Romona didn't think twice recently when she rescued a litter of abandoned baby squirrels. On Facebook, Romona's adoring fans enjoy following her latest paintings and animal escapades.

romonayoungquist.com

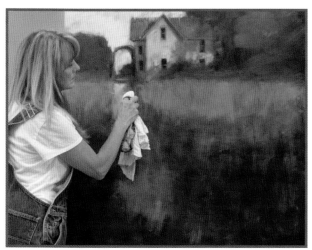

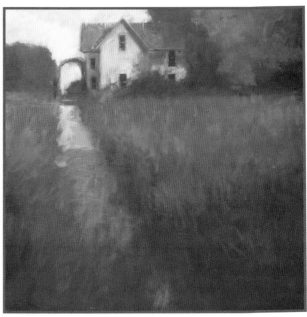

4 Create the Drama

Once again, use a rag or paper towel to wipe out the lights and positive space. Concentrate on shapes, values and design. Working from the focal point out, add more definition to the shapes.

I'm always asking, "What do I want to say?" With this painting, the answer is drama! To achieve this, keep laying in rich darks in the dominant mass, and get some contrast by wiping out the light positive shapes, still keeping it simple and abstract at this point.

Keep the paint to a thin wash, cool colors in shade and warm in the light, always thinking about the value and adjusting. Let it dry overnight and then do a light sanding.

5 Add the Color

Next, lay in the foreground shadow with a cool green, and warm up the area closer to the house with a greenish yellow. Start to define the trees with thicker paint, using a dark, rich green underneath with a lighter warm on top.

Now add color to the house and foreground. Using your palette knife, scrape into the house and tree area, and then soften it with a 2-inch (51mm) hardware brush. Let dry.

6 Lightly Sand the Painting

I will frequently deconstruct because it makes things more interesting. With a light- to medium-grade sandpaper, lightly sand the dry painting. Keep the painting soft and simple, but also leave some hard edges close to the focal point. Step back and squint at the painting.

7 Add Texture

Work the color all over the canvas. See the lavender as a mass, and define a few in the foreground, but keep it simple and concentrate on values. Use a palette knife more at this stage. The paint mixture is getting thicker and more opaque, but still scrape and wipe out to soften edges. Then go back and work more paint on top of the scraped areas.

8 Add the Finishing Touches

The painting is winding down. With nos. 8, 10 and 12 flats and a palette knife, add some details.

In order to make the sun-drenched lavender and house pop, it's important to remember how to play the side-by-side colors with each other. It's not just the lighter color on top that makes the illusion of sunlight happen. Use warm against cool and dark against light.

Put the painting aside for a few days, and make sure it is dry before lightly sanding the surface again. The glaze is the last touch. It will unify the elements in the painting. Use alkyd medium and a touch of a warm transparent color, and glaze the entire painting.

Lavender Sunset
Romona Youngquist
Oil on canvas
60" × 60" (152cm × 152cm)

Romona's Fine Art Tip

I've learned far more from my mistakes than my successes. Happy mistakes are a blessing in disguise.

Painting a Desert Morning

You have a source of inspiration for everything you paint. It may be a photograph, your imagination and the scene in front of you when you paint en plein air, or, as in this case, a sketch based on imagination, observation and some reference photographs.

In *Sunrise on Black Mountain* I was not sure of my saguaro cacti, as I have not painted them much before. A friend from the Phoenix area gave me some good suggestions, which definitely improved the final painting.

MATERIALS

Support
18" × 24" (46cm × 61cm) canvas

Open Acrylic Paints
Bismuth Vanadate Yellow, Burnt Sienna, Burnt Umber, Cadmium Orange, Carbon Black, Diarylide Yellow, Hansa Yellow Opaque, Payne's Gray, Phthalo Blue, Pyrrole Orange, Pyrrole Red, Quinacridone Magenta, Red Oxide, Titanium White, Ultramarine Blue, Van Dyke Brown Hue, Yellow Ochre

Brushes
Nos. 2, 4, 6, 8, 10, 12, 14, 20 flats

Other Supplies
Glass palette or tear-off paper palettes, open gel medium, umbrella

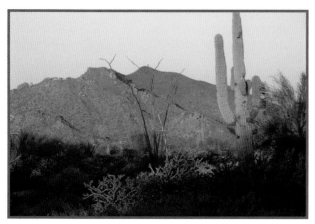

Reference Photo
John D. Cogan has the eyes of a scientist and plein-air painter and is interested in the effects of light, color and atmosphere on his subject.

1 Draw the Composition
A canvas toned with Diarylide Yellow thinned with water sets the mood of the painting. With a no. 20 flat and Red Oxide, draw the elements of the painting. The warm yellow will keep the sunset from becoming too cool. Make changes from the photo to improve the composition. Be accurate—mistakes may haunt you later.

John's Fine Art Tip

Enough cannot be said for the value of having a trusted friend or colleague critique your work before it is finished. That extra pair of eyes may find glaring errors that you were unaware of. It does take a degree of humility to ask for a critique and to receive it graciously.

2 Start the Focal Point

Begin with the center of interest, highlighting the contrasts in value, hue and saturation. The focal point is the saguaro and where the brightest sky meets the mountain. Paint the sky with Titanium White, Ultramarine Blue and a touch of Burnt Umber, continuing with the no. 20 flat. The colors in the landscape are Payne's Gray and Yellow Ochre with a touch of Ultramarine Blue and Titanium White. Note how I exaggerated the vertical form of the mountains to give them more impact.

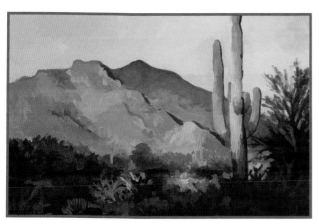

3 Start the Block-In

Using the no. 20 flat, block in the color over the entire canvas. Use a no. 14 flat in the areas where a finer line is needed. Use Burnt Sienna and Red Oxide in the warm areas, with Payne's Gray and Ultramarine Blue. Repaint the sky with the same colors as before, but use a no. 20 flat with synthetic bristles and thicker paint and a dab of open gel medium to facilitate blending. The block-in is rough, though it gives you a good feeling for how the final painting will look.

Artist Profile: John D. Cogan

"It is not the talent; it is the passion you bring to your art that makes the difference."
—John D. Cogan

Whether painting landscapes or wildlife, John D. Cogan captures the essence of the American West on canvas. After earning his bachelor's degree from Texas A&M University, then an M.A. and a Ph.D., John left the corporate world in 1982 to pursue full-time painting.

Working in acrylic paint, John focuses on color and the effects of light. The Grand Canyon has been one of John's favorite subjects. He has painted it hundreds of times in all seasons and weather conditions over the last thirty years. His painting *Out of the Depths* won the Jack Dudley Memorial Fund Purchase Award and is in the Grand Canyon's permanent collection.

I first met John in Jackson Hole, Wyoming, many years ago at a gallery event. I remember being impressed with his light-imbued paintings and attention to detail. John's serene manner and love of nature can be felt in his acrylic paintings. He has really mastered the acrylic medium. It is a thrill to have John contribute his extensive knowledge with us in this book.

johncogan.com

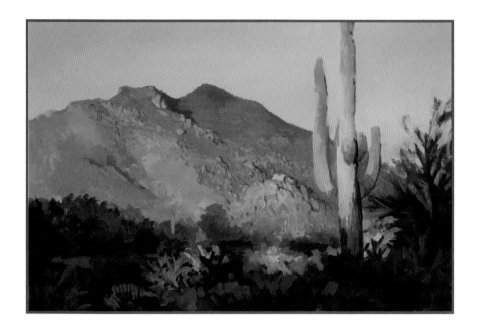

4 Paint the Mountains

With a no. 12 flat with synthetic bristles, begin to apply the paint more heavily and use nos. 4, 6 and 8 for the detailed work in the rocky surface of the mountain and the foreground. In the foreground, it's time to add more of the primaries including Diarylide Yellow and Hansa Yellow Opaque for the foreground green areas along with Pyrrole Orange and Cadmium Orange for warmth in the greens. Use Titanium White, Ultramarine Blue and Quinacridone Magenta to balance the browns in the mountains. Use thicker paint to accentuate texture.

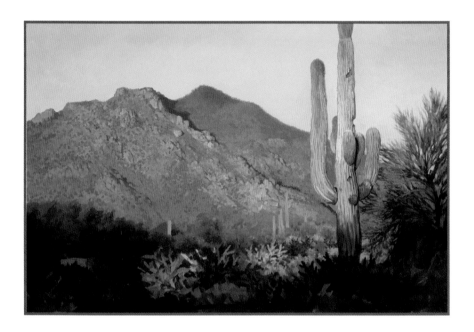

5 Paint the Saguaro

As the mountains near completion, begin working the main saguaro and the foreground. In this step continue using flat bristle brushes: no. 12 for the large areas and nos. 8, 6, 4 and even occasionally a no. 2 for the finest details. The saguaro is the center of interest. Make sure it is right. Refine edges and adjust the colors. Use the full range of colors in the foreground, introducing more Pyrrole Orange and Pyrrole Red in the warmest areas and saturating the green accents with Hansa Yellow Opaque.

John's Art Business Tip

A professional artist is one who devotes all of his energy to fulfilling the passion, the desire to create.

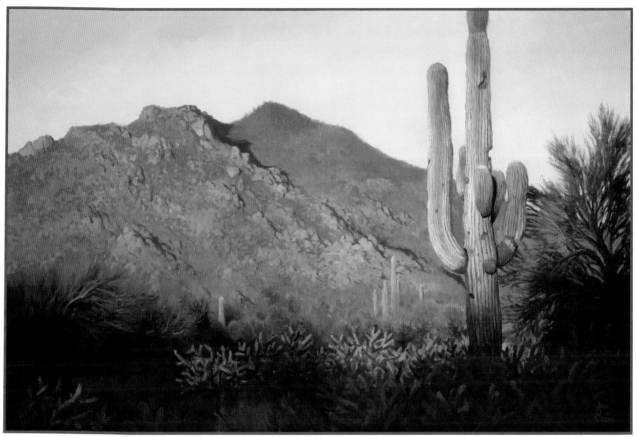

6 Finish With Fresh Eyes

Use nos. 4, 6 and 8 flats to add the last details and minor adjustments to the foreground. With a no. 10 flat, apply a thin glaze of gel medium mixed with Pyrrole Orange and Diarylide Yellow to brighten the cactus and other foreground elements. Add a small bit of Phthalo Blue to the glaze to alternatively go warmer or slightly cooler as needed. Note the change made from the photo to improve upon the painting.

Sunrise on Black Mountain
John D. Cogan
Acrylic on canvas
20" × 30" (51cm × 76cm)

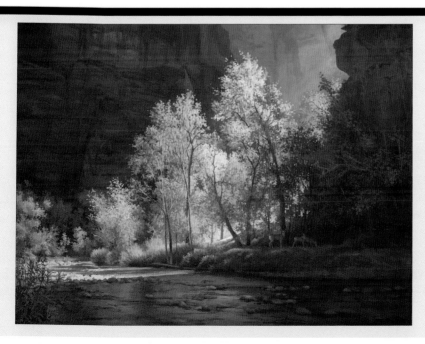

Dramatic Lighting

John D. Cogan used the warmth of the trees back-dropped by the cool mountain cliffs to create a dramatically lit scene. To add to the backlit glow, John used an opaque scumble over the farthest mountain cliffs to brighten them.

The Garden of Zion
John D. Cogan
Acrylic on canvas
18" × 24" (46cm × 61cm)

Creating Atmosphere and Distance in Pastel

I photographed this scene early one May morning when the shadows were still long and the grass was dewy. I knew immediately that I wanted to pump up the color and play with a complementary color scheme of green and rust. I also wanted to create a feeling of distance.

MATERIALS

Support
24" × 18" (61cm × 46cm) sanded pastel paper mounted on board

Pastels
#305 Spruce Blue NuPastel
Other various hard, medium and soft pastels

Brushes
Old bristle brush (new ones will be eaten up by the sanded paper)

Other Supplies
Odorless mineral spirits or denatured alcohol, soft lead pencil, watercolor or diluted acrylics, workable fixative

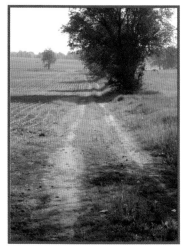

Reference Photo
I take hundreds of photographs and am always looking for scenes with a strong composition and interesting shapes to paint. I used this reference photo as a starting point, but I was not afraid to adjust the colors to suit my needs. Don't be afraid to do the same!

1 Create the Underdrawing

Choose a light-colored sanded paper that is pre-mounted on a board to avoid buckling. Use watercolor or diluted acrylic to cover the board with a rust or orange underpainting. The paper does not have to be evenly covered. In fact, it is often more interesting when the wash is not perfectly opaque and flat.

Grid up your composition in the same proportion as your original reference photo, making changes as you see fit. Create a light pencil grid, then boldly draw in the darkest areas with a #305 Spruce Blue NuPastel. Take an old bristle brush loaded with odorless mineral spirits or denatured alcohol and brush freely over the dark areas. This will create a permanent underdrawing that does not become muddied or smeared with subsequent layers of pastel.

Jill's Fine Art Tips

- To portray distance in a painting, the elements that are farthest away become bluer and lighter as they recede. They are also fuzzier and less detailed.
- Cameras can never catch the true color that we experience in nature, and the point is not to recreate a photo anyway. Feel free to deviate from references at any point to improve your painting.
- Print and view both your reference photo and painting in black and white to check that the black-and-white values are correct.

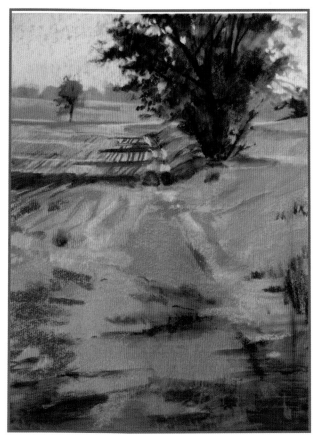

2 Start the Underpainting

Using pastels of medium hardness, begin to lay in color very lightly over the orange background. I like to use Rembrandt pastels for this stage of the painting.

Start by choosing some shades to represent your lightest lights and your darkest darks. They should be close to the final values. This will give you the range of darks and lights that the rest of your colors will have to stay within.

Cover the rest of your paper with value-appropriate colors with a very light touch. Part of the beauty of this type of underpainting is that you can leave some of it showing through your pastel layers.

Use complementary colors to get an interesting "vibration" of colors. In this case I used a rust underpainting for a predominantly green final painting.

Choose hues that are brighter and richer than your reference photo. Note that there is very little detail at this point, just a general nod to the color and placement of the main elements of the scene.

Give the board a light spray with workable fixative at this point. However, to avoid darkening of colors, don't use it on the later layers.

Artist Profile:
Jill Stefani Wagner, PSA

"Paint what makes your heart sing."
— Jill Stefani Wagner, PSA

Whether painting landscapes, cityscapes or figures, artist Jill Stefani Wagner's primary focus is always "light" and how it affects the scene. Working in pastel, oil and watercolor, she approaches her paintings as a sculptor would, carving the nuances of highlight and shadow.

Jill received a B.F.A. in painting from the University of Michigan School of Art and Design and owned an award-winning advertising firm before "seeing the light" and becoming a full-time painter. Now a busy professional artist, Jill paints 175 to 200 paintings a year.

Jill has been honored with multiple awards from the Pastel Society of America and has been featured in important art magazines including *Pastel Journal* and *Fine Art Connoisseur*.

Realism with a painterly twist best describes Jill's jewel-like paintings. For Jill, painting is an endless adventure. It is my pleasure to share her pastel painting demo in the pages of this book.

jillwagnerart.com

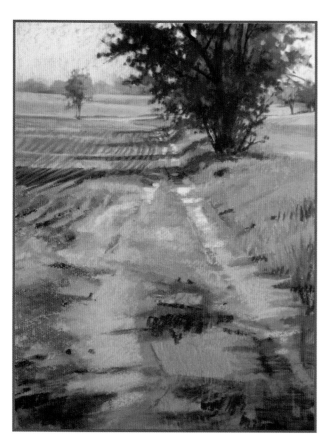

3 Work on the Colors and Values

Now the fun begins. Start comparing your colors and values. Establish the colors you want to use in your sky and the far tree line. When those are in place, you can begin working forward into the painting, using hues that are a little warmer and more vibrant as you come to the bottom. Also, as you move closer to the front of the painting, a bit more detail will become evident. Make your pastel strokes mirror the direction of the element you're painting (e.g., for the grasses in the foreground, use vertical, spiky strokes, while the distant, rolling hills can be described with soft, horizontal passages).

Re-establish your highlights and deep shadows at this point, making sure that the area of most contrast is close to your focal point (in this case, the large tree). Note that the shadows are not one uniform color as they fall over different surfaces, but they are the same percentage darker than what is beneath them. For example, in the left of my painting, sunlit rows of new corn are brighter than the dark dirt. Accordingly in shadow, the corn is a darker color but still brighter than the dirt. As shadows fade into the distance, you see less and less of this variation in value.

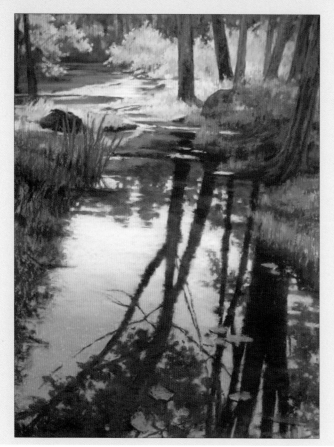

Beyond the Reference Photo

Reflections on water are a recurring theme in my work. I love the abstract shapes and colors that occur when light reflects onto a wooded stream.

To paint this painting I used the same techniques as described in the demonstration. The painting started with a warm orange tone over the whole paper. To create distance, the elements in the background are less detailed and the far woods take on a muted blue-gray color. The photograph did not show this color shift, but I know from working outdoors that our eyes register this phenomenon in nature. As artists, we often need to "push" what we see in our reference photos to create a scene that reads correctly to the viewer.

Parker Mill Creek 2
Jill Stefani Wagner, PSA
Pastel on sanded paper mounted on board
24" × 18" (61cm × 46cm)

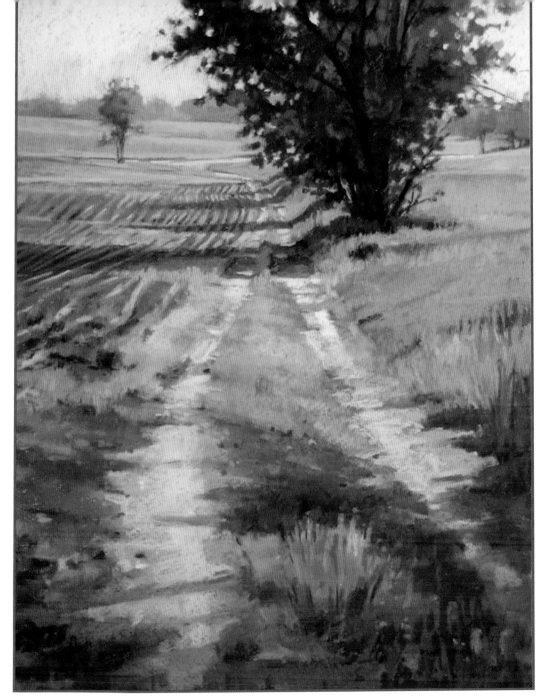

4 Add the Finishing Touches

Continually compare and re-evaluate the values to make sure they ring true. Darken and lighten areas that need additional attention, but do not fill the entire tooth of the paper. Let some of the orange show through, especially at the bottom where the colors would be the warmest.

Save your softest pastels for the highlights that you apply at the very end. Keep most of the detail at your point of interest so that the observer's eye goes there first, allowing the rest of the information to be "filled in" by the viewer. Stop before you think you are finished!

Rogers Farm
Jill Stefani Wagner, PSA
Pastel on sanded paper mounted on board
24" × 18" (61cm × 46cm)

Jill's Fine Art Tip

I absolutely love painting outdoors. What I learn in the field greatly improves the color and light in my studio paintings as well. I've heard many artists say that you have to paint at least five hundred plein-air paintings before you really get it.

A Clear Path to a Finished Landscape Painting

MATERIALS

It's a jungle out there, and sometimes it's easy to get lost within the painting process. With these easy steps you can stay on the path and keep from being overwhelmed with the process.

This system is how I've now been working for over three decades. Oftentimes, my biggest issue is simply getting started on a new painting. But ingraining these steps is like having a map to get you where you want to go.

Steven's Fine Art Tip

Amateurs in any discipline are always in a hurry to get to the "fun part." Put more time and effort into the early stages. If the drawing and values are correct, the painting will flow from here.

Support

24" × 40" (61cm × 102cm) canvas

Oil Paints

Alizarin Crimson, Burnt Sienna, Burnt Umber, Cadmium Yellow Deep, Cadmium Yellow Light, Cadmium Red Light, Cerulean Blue, Cobalt Blue, Naples Yellow, Raw Umber, Sap Green, Titanium White, Ultramarine Blue, Yellow Ochre, Zinc White

Brushes

Nos. 2, 4 egberts

Other Supplies

Alkyd medium, charcoal, glass palette, paper towels, small oval palette knife, spray fixative, turpentine

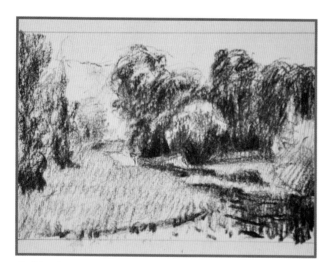

1 Start With the Design

This stage is the backbone and most crucial for future success. A strong foundation holds everything in place.

Subject always boils down to one thing: what you are passionate about. Passion will sustain you and imbue your work with intangibles achieved only from excitement for your subject. Only you know what you love; now paint it. For one person it may be flowers, and for another it may be roadkill (don't laugh, I've painted both!).

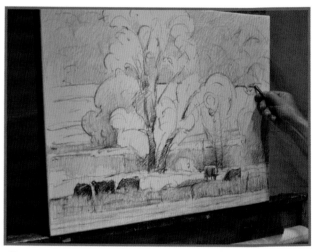

2 Create the Drawing

Make sure your design is the same scale of your canvas. Otherwise, revisions must be made on the fly and drawing intends to solve problems ahead of time. Draw several sketches before choosing one, or design it using Adobe Photoshop, moving, adding and deleting elements easily to whatever end feels right. Then draw directly onto the canvas, using charcoal or thinned paint. After the drawing is complete, seal it with spray fixative. This way, a ghost of the drawing will be retained when you apply the monochromatic underpainting.

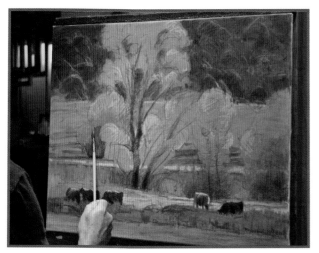

3 Create the Underpainting

The key here is to find and build correct value. Use thinned paint with turpentine for the initial large washes applied with a paper towel. The colors used are Yellow Ochre, Burnt Sienna and Burnt Umber. Use a no. 2 or 4 egbert bristle brush for the underpainting. I prefer egbert brushes because they create a fluid line, and, like a maestro, I can keep the strokes rolling and loose.

Let it dry overnight before the next stage.

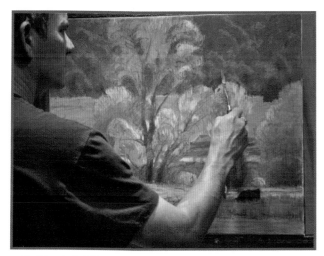

4 Start Adding Colors

When painting landscapes, predominantly work top to bottom and back to front. Use these steps to guide yourself through difficult stretches. I use all the colors on the palette during this step and apply the paint with a small oval palette knife.

Beautiful color harmony is elusive and a cause of frustration for many a would-be artist. One easy way to create color harmony is to mix a large pile of sky color and use that as the base for all other colors in the painting, adding color as you come forward on the picture plane. For these piles I used Titanium White, Raw Umber and then varying degrees of Cobalt Blue and Alizarin Crimson. I have no system for mixing color—I do it by feel. I am always trying to gray down my colors from the start so there is room to come up in chroma later if I so choose.

Artist Profile:
Steven Lee Adams

Steven Lee Adams and I are longtime friends. Each year, I look forward to painting with him during our mutual plein-air gallery events. His keen sense of humor helps to make the time fly by.

While painting in the field, Steven's work is more akin to the Impressionists, whose main focus was capturing the atmosphere of a specific moment in time. In his studio, Steven searches for the intangible feeling of timelessness within his artwork, which is inspired by Whistler, Inness and Twachtman of the Tonalist movement.

A hands-on artist, Steven takes great pride in the presentation of his finished paintings. In the tradition of Whistler, Steven masterfully builds, carves and gilds his own museum-quality frames.

I have great respect for Steven as I have watched him overcome many challenges, including the loss of a child. Yet through life's hard knocks, Steven has overcome adversity and continues to grow and test himself personally and as an artist.

Steven is also a natural-born salesman and innately knows just how to use Facebook. He strikes the perfect balance between branding and marketing as he entertains his captivated Facebook followers with tales from his plein air travels and adventures.

stevenleeadams.com

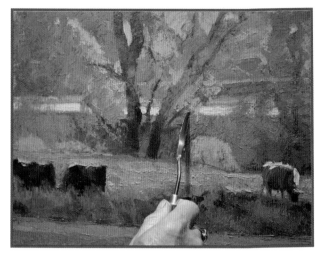

Mixing Colors

When mixing for a color field (sky, mountain, fields), mix three related colors: First, with a small oval palette knife, mix the main pile as a neutral base (middle pile). The other colors are created from that main pile by mixing two smaller piles, one warmer (left pile) and one cooler (right pile). These three tones or colors are juxtaposed throughout to create movement and interest.

5 Knit the Painting Together

When the entire canvas is covered with color, go back with a palette knife and knit each separate color field together. At this point the gesso ground has pulled some oil from the paint, and it is usually the perfect consistency to knit edges.

Using the palette knife, keep the edges crisp to lead the eye to the focal point. With a no. 2 egbert, soften and blend some of the edges to lessen tension and reduce competition with the focal point.

Using a Palette Knife

Morning on the Seine is from a trip Steven made to Paris. During the color application he worked predominantly with one palette knife. He likes how the knife creates random, organic marks, which can be easily seen in the painting. The palette knife helps Steven keep from trending toward specificity early in the process.

Morning on the Seine
Steven Lee Adams
Oil on canvas
36" × 36" (91cm × 91cm)

6 Scumble or Glaze to Finish the Painting

After the alla prima (wet-into-wet) of Step 5 it is rare to have a completed painting, but it does occur. If not, one of these following steps can help. Make sure the painting is dry to the touch before proceeding.

Try scumbling. This involves painting over a previously painted area with a small amount of opaque color suspended in an alkyd medium. Use it to lighten or darken values or backgrounds. Too much opacity will bury work you've already done, so use it for subtle shifts only.

Glazing is another option. It is the same as scumbling but uses a transparent or semi-transparent color instead of an opaque. Glazing can help tone down a color's intensity. You can also improve an area that's too rich by glazing with a complementary color, or bump up the intensity of a color with a glaze.

Glazing helps unify and integrate paintings. When everything feels out of balance in a painting it makes sense to integrate dissimilar elements with an overall glaze. Mix several transparent colors to find a warm neutral tone, then glaze and unify the entire painting.

Light at Mid-Day Study
Steven Lee Adams
Oil on canvas
24" × 40" (61cm × 102cm)

Steven's Fine Art Tips

- Scumble = opaque.
- Glaze = transparent.
- Find info about a color's transparency on the back of the paint tube.

The Importance of Touch Using Pastels

The artist's touch, or how lightly or heavily pastel is applied, can affect the outcome of a work in this versatile medium. This facet is often overlooked and rarely stressed, but is so important, particularly in rendering the effects of light.

The very first thing I do when painting any work is to decide on what to paint. I look for a view with a good balance of light and shadow that will translate well into pastel. These magnificent cottonwood trees at the edge of a small cattle reservoir called out to me.

MATERIALS

Support

UArt 400-grit sanded paper mounted to an acid-free foam board

Pastels

Terry Ludwig, Girault, some Great American Art Works and Rembrandt

Other Supplies

Acrylic paint in Mars Violet and Ultramarine Blue (for toning the paper), soft bristle brush, soft vine charcoal

1 Tone the Paper and Start a Value Drawing

Tone the paper to a middle value violet-gray with a watered-down acrylic wash of Mars Violet with a touch of Ultramarine Blue. With a soft vine charcoal, draw the compositional lines and mass in the darks for a value sketch. Use sweeping arm movements with a light touch.

2 Mass in the Values

Begin with the pastel colors with the lightest lights. Using the side of the pastel, make sidestrokes and block in the sky, the large tree shapes and the light on the bank and background rocks. This will establish the value range. The lights are the pastel, the darks are the massed charcoal shapes and the midtones are the paper.

Christine's Fine Art Tip

Have all your functional studio furniture on wheels. You can discover inexpensive department store finds, such as laundry carts for supplies and office open bins that are stacked. This way, everything can be moved around and cleared away easily when you have a collector visit. My moveable counter-height tables even double as a bar during open studios!

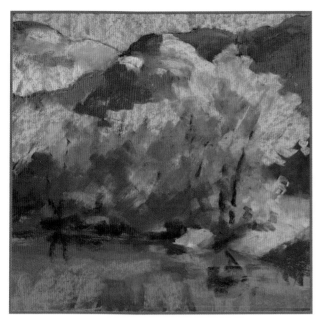

3 Refine the Shapes

Working between light and dark, mass in the distinct foliage and rock formations. Look closely at the large shapes and decide where to vary the color. Pick out more trunks and branches in the trees, refining shapes, making sure to have variation in size and direction of the strong verticals. Remind yourself to keep the shapes simple, and deliberately keep the color of the rocks subdued so the focal point will be the colorful trees.

Step 3 Detail
Use an old soft bristle brush (I used a soft synthetic no. 6 flat) to lift strokes for correction throughout the painting process. Adjust the rocks for a better contrast.

Artist Profile:
Christine Debrosky

"The whole world is a garden if you look the right way."
—*Francis Hodgson Burnett*

For Christine Debrosky, pastel is literally a hands-on medium. The artist's touch is so important in rendering the light effects for which she is known.

While growing up in the Hudson Valley, Christine watched the winter landscape with its hues of light turn to deep summer, surrounded by every shade of green. Christine knew she wanted to be an artist.

Once an award-winning watercolorist, Christine was introduced to the rich jewel tones of pastel by taking a workshop with Albert Handell. Her work in this medium has garnered rainbows of ribbons. Working en plein air with nature has been an invaluable learning experience.

Today she exhibits with such prestigious groups as the Oil Painters of America, the Pastel Society of America and the American Impressionist Society.

I look forward to seeing one of Christine's dazzling pastel paintings dance across my Facebook feed. It is a joy to include her valuable knowledge of pastel in my book.

christinedebrosky.com

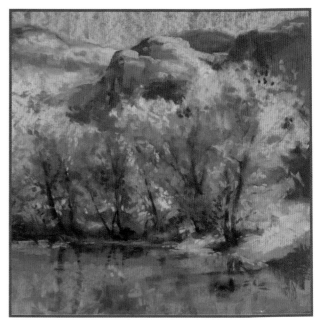

4 Use Heavy Pressure

Now start to apply heavy pressure with the pastels in the treetops that are in light. Pay attention to the direction of the strokes. With the end of the pastel stick, use shorter, choppier strokes to mimic leaf shapes. Some of my strokes are heavy, and some are light, depending on whether I want to add strong color or blend what is already down with the pastel. Reinstate dark areas as needed with the charcoal, which is compatible with the pastel.

5 Add the Details

This stage involves refining shapes and intensifying colors, especially in the main tree. Some strokes are heavy, and some are light. Here is where touch really comes in. Continue working the sky with woven strokes, going in differing directions and adding more color. Work around small shapes to indicate the shrubs hanging on the rock tops. Using your fingers with pastel on them, "print" some of these small, delicate shapes. Now go to the water. The tree shapes must be set before painting any reflections of them. This is done with light horizontal and vertical strokes. Now, methodically work down from the top and add some warm reflected light to the rocks. For the treetops, press hard with the pastels, even to the point of breaking some! Paint the negative space of the tree holes and scatter a few fallen leaves on the surface.

Christine's Fine Art Tips

- In photos, shadows can appear to have very dark, "dead" color, whereas a plein-air study has rich warm tones to refer to.
- Choose a color of paper that compliments your subject.
- Knowing when and where to place varying strokes is akin to good brushwork in oil painting.

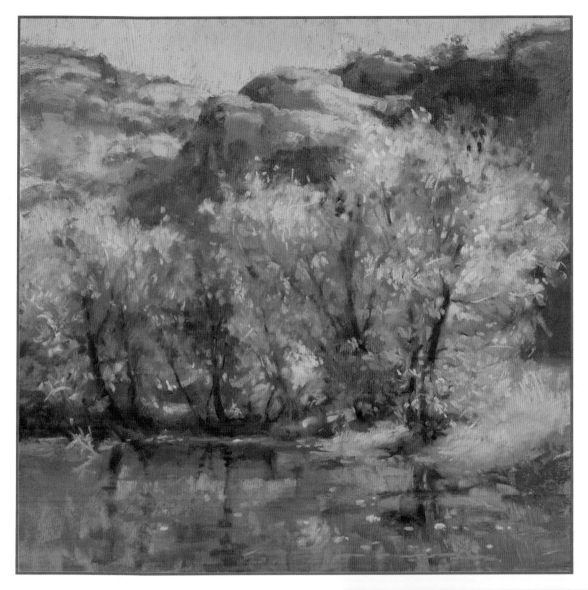

6 Add the Finishing Touches

The final step is to "glaze" the painting. In pastel painting, glazing is used to unify and add a light veil of color over some areas. Use a hard pastel in a color close to the original tone of that area.

Use harder pastels, mostly Giraults, with a very light feather touch. This unifies some areas and pushes some back. It is a delicate dance across the surface.

Precious Gold
Christine Debrosky
Pastel on UArt paper
18" × 18" (46cm × 46cm)

Step 6 Detail
Punch the focal point of the main tree with soft, rich Terry Ludwig pastels in some heavy, "juicy" strokes. In pastel painting there can be heavy impasto. Add some jazz with small spots of intense color in key areas of the painting.

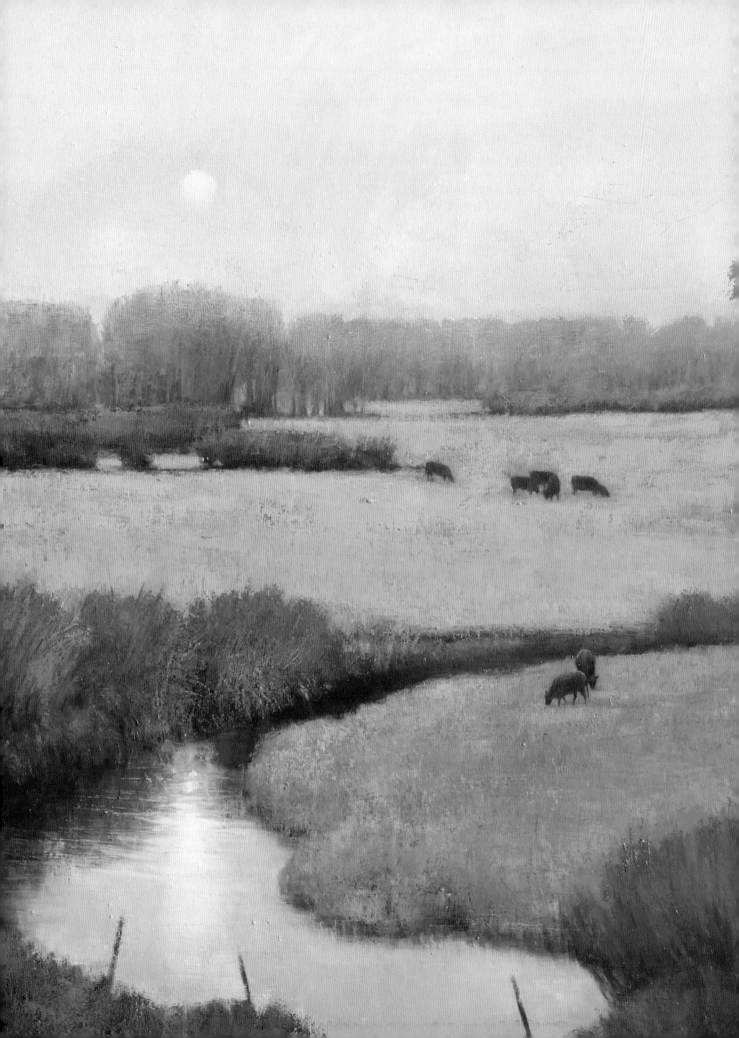

Wildlife

Dating back to prehistoric cave paintings, wildlife drawing and painting are mankind's earliest art forms. The first artists were most likely wildlife artists! These ancient painters decorated cave walls with smearing, brushing, dabbing and spraying techniques. They primitively depicted the natural world with the animals that were important and symbolic to them.

Through the centuries, artists have documented the flora and fauna of explored areas. Nevertheless, wildlife has been a challenging subject for the artist. Wild animals are tricky to find and unlikely to keep still long enough to sketch, let alone to paint! Animal skins and taxidermied specimens are useful as reference material, but modern photography has made wildlife art much easier to accomplish more accurately.

Today, painting techniques can range anywhere from tightly rendered scientific illustrations to impressionistic, painterly or even abstract approaches. Wildlife subjects can also encompass domestic and farm animals. Some artists choose to make the animal the focus of the painting, while others prefer the animal to be subordinate to its natural environment. Because of this, wildlife artists must also be proficient landscape painters, as well as have an acute understanding of animal anatomy.

The wildlife artists within these pages are all passionate about using their art as a way to inspire appreciation and conservation for nature through their depiction of mammals, birds, sea life and other creatures.

Western Reflections
Lori McNee
Oil on linen
40" × 30" (102cm × 76cm)

Wildlife Inspiration

The artists in the following pages share their adventures with nature through paint. They all share a deep reverence for wildlife and the environment. Wildlife art enriches and inspires knowledge and appreciation for humanity's relationship with nature.

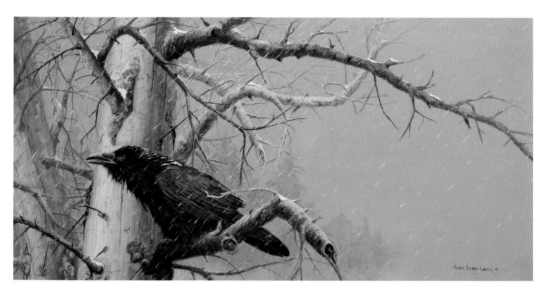

Sudden Flurry
Suzie Seerey-Lester
Acrylic on panel
15" × 30" (38cm × 76cm)

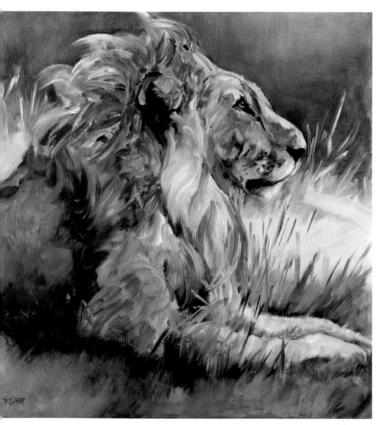

Out of Africa
Linda St. Clair
Oil on canvas
48" × 48" (122cm × 122cm)

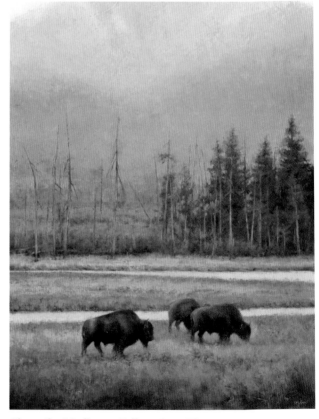

Along the Madison—Yellowstone Bison
Lori McNee
Oil on linen
40" × 30" (102cm × 76cm)

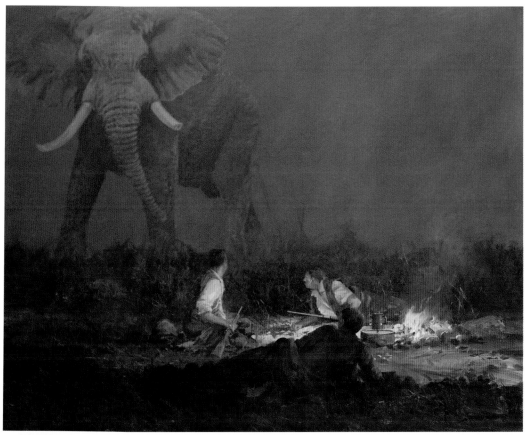

Night Terror
John Seerey-Lester
Oil on panel
24" × 30" (61cm × 76cm)

India Ink
John Seerey-Lester
Acrylic on Belgium linen
36" × 36" (91cm × 91cm)

Northern Visitor
Lori McNee
Oil on panel
10" × 10" (25cm × 25cm)

Painting Animals With Emotion Alla Prima

My paintings of animals are full of life and emotion. So, even though anatomy is a huge concern, it is not my priority. My attempt is to create an image that will convey a feeling.

It is also imperative to spend time in the field with the animals you are painting. Even though I work from photographs most of the time, I know how the animal moves, its mannerisms, its environment and even how it reacts to certain situations. It may be subliminal, but this knowledge goes into your paintings. Above all, paint what you love and have fun with it.

MATERIALS

Support
30" × 30" (76cm × 76cm) gallery-wrapped canvas

Oil Paints
Alizarin Crimson, Cadmium Red Light, Cobalt Blue, French Ultramarine Blue, Maxima White, Sap Green, Transparent Orange, Transparent Red Oxide

Brushes
Nos. 0–12 filberts
3-inch (76cm) very soft flat

Other Supplies
Soft charcoal

1 Make a Charcoal Drawing
Start with a very loose drawing in soft charcoal. Be very gestural with the drawing. I am not a linear artist, so I create my paintings with the paint by contouring and shaping with form and color.

Linda's Fine Art Tips

- Keep your colors clean. Even if it means cleaning your palette often and wasting paint, it's worth it.
- Make deliberate strokes with confidence and keep it loose.
- Use complementary colors, value changes and edges to bring attention to the eyes.

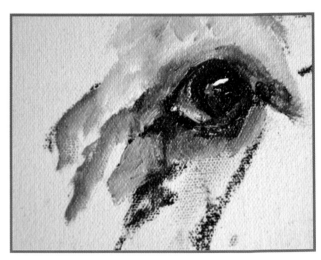

2 Start With the Eyes
Always start with the eyes. That is where the soul of the animal lives, and you can portray so much emotion with the eyes.

Start with a dark mixture of Alizarin Crimson, Sap Green and French Ultramarine Blue to create the dark for the pupil (do not use black). Then paint the outline of the eye with Transparent Red Oxide. Add the highlights with French Ultramarine Blue mixed with Maxima White and then a spot of pure Maxima White right next to it.

Leave one edge of the highlight hard while softening the opposite edge. Edges are extremely important here. For the most part, keep them softer and looser. Put pure rich color around the eyes to draw the viewer's attention there.

3 Paint the Nose

To paint the nose, use the same dark mixture as used for the eyes. Mix Cadmium Red Light with Transparent Red Oxide for the lower portion of the nose. This will give the illusion of reflected light and will help give roundness. Also add some white highlights around the nostrils and on the top part of the nose.

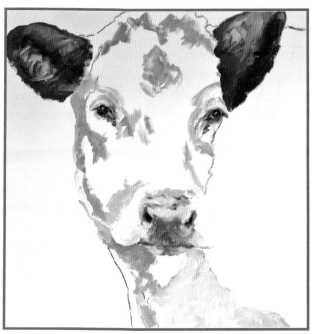

4 Paint the Shadows

Begin to create the shadows in the face. Work all over the painting adding blues, purples and so on. Paint the ears using Transparent Red Oxide and French Ultramarine Blue for the dark parts of the ear and Transparent Orange and Maxima White for the lighter areas. You might want to add a bit of Cadmium Red Light.

Artist Profile: Linda St. Clair

"I want my work to tell a story, to make us feel a connection with the subjects, to remind us all that upon closer inspection, animal emotions and relationships are not unlike our own."
—Linda St. Clair

Linda has set herself apart as an innovator who creates animal portraits. Whether of the barnyard, domestic or wild variety, the animals and their vital energy inspire Linda's paintings.

These signature paintings are characterized by the expert play of warm and cool colors, loose brushstrokes, bold color and thick and thin textural passages. Each alla prima painting is completed during a single, intense session out of her studio in Santa Fe, New Mexico.

Linda travels the world in search of new and interesting animal subjects. Her curious spirit has taken her to such wild places as the North Pole, Africa and Alaska.

It is fun to follow Linda's outdoor adventures on Facebook. I always look forward to seeing Linda's newest creations inspired by her travels.

Linda's paintings are exhibited and collected throughout the nation and worldwide. She is a two-time recipient of the Grumbacher Gold Medal and a member of the Society of Animal Artists in New York.

lindastclair.com

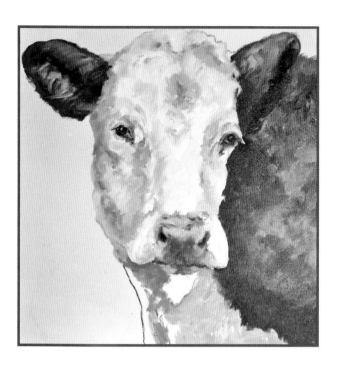

5 Add the Lights

Now mix the lights. Use Maxima White with a tiny bit of Transparent Orange. This is much thicker paint at this point. As you apply the paint, let the brush pick up bits of the darks and blend them. Actually, a lot of my mixing is done on the canvas.

Cover the whole drawing with paint and come back with a 3-inch (76mm) very soft flat and gently blend. Go over the lights, into the darks, gently blending the edges so that there is not a hard transition from dark to light.

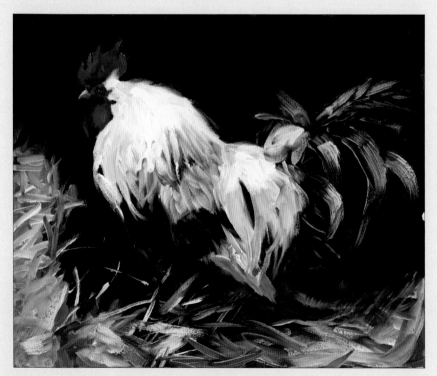

Keep It Simple

Linda advises artists to say more with less. You don't need to put in everything, just enough to convey your message. This simple yet forceful painting of a rooster exemplifies this principle.

Renegade Rooster
Linda St. Clair
Oil on canvas
18" × 24" (46cm × 61cm)

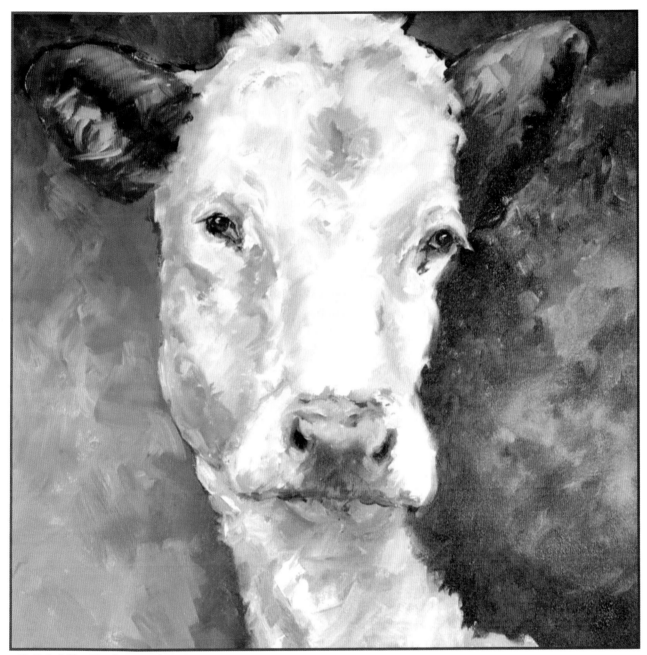

6 Paint the Background

The background goes in at the very end. Use the same colors that are in the painting of the animal. Again, with a soft brush, blend one color into the other. Repeating the same colors that are in the animal gives the painting continuity and finesse.

For the Love of Grace
Linda St. Clair
Oil on gallery-wrapped canvas
30" × 30" (76cm × 76cm)

Linda's Art Business Tip

Make your galleries your partners. Do not leave your career up to them to develop. That is your job. If you make them feel they are your partners it will go a long way toward great relationships and sales. Remember, you have to have paintings that are well-executed and appealing. Beyond that, whether a collector or a gallery, its all about relationships.

How to Paint a Lifelike Owl

Birds are magical little beings, but capturing their likeness in paint can seem quite challenging. Achieving the illusion of feathers is easier when it is broken down into simple steps. These steps can be applied toward painting any bird species. It is fun to watch your bird come to life with each stroke!

For this demo I chose to paint with Cobra water-mixable oil paints on Arches Oil Paper mounted on board. The paper is soft and will help create the illusion of fluffy owl feathers without too much fussy detail.

MATERIALS

Support
Arches Oil Paper mounted on hardboard panel

Oil Paints
Burnt Sienna, Cadmium Orange, Cadmium Red Light, Cadmium Yellow Light, Naples Yellow, Permanent Green, Raw Umber, Titanium White, Ultramarine Blue, Yellow Ochre

Brushes
No. 0 round sable

Nos. 4, 6, 8 flats

Nos. 2, 4, 6 rounds

Nos. 2, 4, 8 filberts

Other Supplies
Burnishing tool (bone folder, back of a spoon, ice pop stick), charcoal pencil, Cobra glazing medium (alkyd medium can be used instead with traditional oils), Cobra painting medium, freestanding light stand with a 100- to 150-watt bulb, reference materials, spray fixative, toothpick, tracing paper, water (turpentine or odorless mineral spirits can be used with traditional oils)

1 Transfer the Drawing
With a charcoal pencil, draw the basic outline of the owl onto tracing paper. Once you are happy with the drawing, position it on a toned panel or canvas with the charcoal side down (the tracing will be backwards!).

Next, use a blunt burnishing tool to rub the back of the drawing until the charcoal transfers onto the surface of the toned panel or canvas. With care, lift a corner of the drawing to see if the owl drawing has completely transferred. If not, replace it and rub again.

Lori's Art Business Tip

Making the leap from a novice or hobbyist to a professional artist requires smart business sense, which includes a balance of good marketing and branding skills.

Lori's Fine Art Tips

- Painting feathers or fur is a lot like laying shingles or shakes on a roof. You start laying them from the bottom up. This is the same way we place our paintbrush strokes!
- For extra-fine feathers, try using a toothpick or straight pin.
- A great way to find drawing mistakes is to turn the painting upside down or look at it backwards in a mirror. It really helps with the eyes.

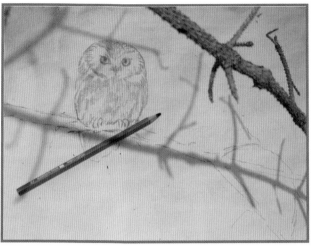

2 Draw the Branch

Here's a little trick I use sometimes: Find a real tree branch to use as reference material. Next with a lamp or another single light source, cast a shadow from the branch onto the panel. Once you are happy with the shadow design, trace over the shadow with the charcoal pencil. Spray the drawing with workable fixative. You can also use this tip during the progressive stages of the painting. At that point, use a no. 4 or 6 round with Raw Umber to copy the silhouette onto the surface.

3 Establish the Form

Use good reference materials of your subject. I enlarged a variety of saw-whet owl photos on my computer screen to the left of my easel.

With a no. 2 round and Burnt Sienna thinned with water (or odorless mineral spirits if using traditional oils), trace over the charcoal drawing. The oil paper easily absorbs the paint and sets up quickly. Now you have the basic shape of the owl for a roadmap.

With the thinned Burnt Sienna and a no. 4 filbert, begin the block-in of the owl and the branches. Add a little Ultramarine Blue to the Burnt Sienna and start loosely establishing the darker areas on the head, under the face, tail and eyes with a no. 4 filbert and no. 2 round.

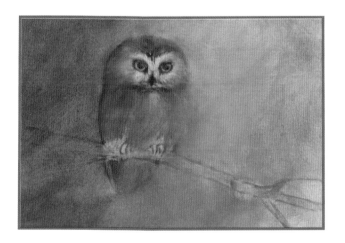

4 Block In the Local Color

The saw-whet owl looks like a monochromatic bird, but upon further inspection you will see a lot of color variation. Break its form into areas of local color. With a no. 4 filbert, block in the body and the outer area of the head with a mid-tone value using Burnt Sienna and painting medium. Add a bit of Cadmium Orange to this mixture in some areas and a touch of Permanent Green and Yellow Ochre in others. This creates a great midtone to build the fluffy creamy white feathers upon. Keep the edges soft.

At this point of the painting, continue using the painting medium with the mixtures. Mix up Burnt Sienna and Ultramarine Blue and block in the shape of the eyes and the pupils and beak with a no. 2 round. To make it even darker (if needed), add a little Raw Umber to the mix. Use Yellow Ochre and a touch of Cadmium Yellow Light for the yellow of the eyes.

Paint the owl's face with Naples Yellow, Titanium White and a touch of Ultramarine Blue around the lower eye area with a no. 2 filbert. Use Naples Yellow, Titanium White and a touch of Cadmium Orange for the upper eye area. Use a no. 2 round to begin the illusion of feathers.

Build up several coats of the above mixtures until you achieve an opaque base. With a no. 8 filbert, rough in the background with a mixture of Naples Yellow, Burnt Sienna and a touch of Permanent Green.

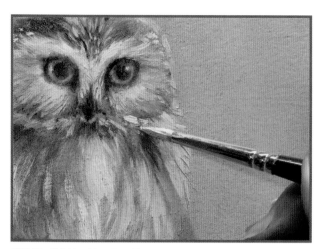

5 Build Up the Feathers

Build the feathers, keeping in mind the light is coming from the right. For the illusion of outdoor light and form, keep to the warm light and cool shadow principle.

Use a no. 2 round and no. 4 filbert for the feathers. Being mindful of the feather patterns, begin to build up the lighter colored feathers. Mix Naples Yellow, Burnt Sienna and a touch of Ultramarine Blue for the undercoat of light feathers in shadow. Mix Naples Yellow, Burnt Sienna and Cadmium Orange for the lighter feathers in sunlight. Use painting medium to help the paint flow.

Add a few darks with Burnt Sienna mixed with Ultramarine Blue under the chin and around the face. Load the paintbrush and drag it in the direction the feather grows. Add thicker lights around the face to create more feather texture and depth.

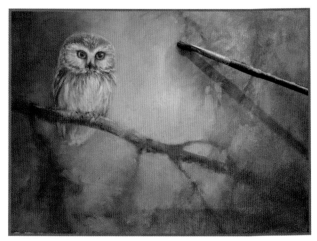

6 Paint the Background

Block in the tree branches with a no. 6 flat or filbert and Burnt Sienna, Ultramarine Blue and Cadmium Orange. Next, with a no. 4 flat or filbert, block in the pine tree boughs with Raw Umber, Permanent Green, Ultramarine Blue and Yellow Ochre. Add a few details to suggest smaller branches with a no. 2 round and the tree branch mixture.

With a soft no. 8 flat, thicken the green backdrop while keeping the darker areas fairly transparent. Soften some of the owl's edges into the background. Let dry for a day.

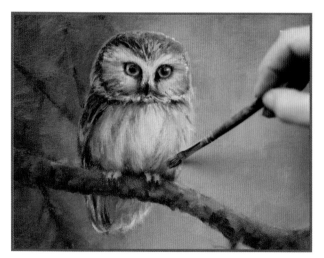

7 Start Glazing

Once the painting is dry to the touch, add glazes to adjust color and temperature. Mix a transparent puddle of Burnt Sienna, Permanent Green and Yellow Ochre with a bit of water and glazing medium. Apply the paint with a no. 2 filbert to give the owl weight under the belly. This will help the owl sit on the branch. Glaze the tail, under the left wing, under the cheeks and sparingly around the eyes. Add a touch of Cadmium Red Light mixed with glazing medium to warm up a few of the feathers.

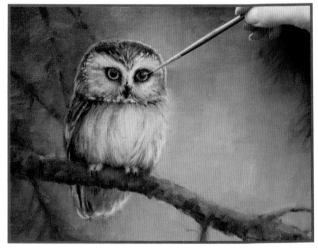

8 Add the Eye Highlight

The eyes are very important to capture the personality of the owl, so their highlights need to be refined. The brightest highlight will be in the eye that is closest to the light source (the eye on the right). With a no. 0 round sable, use the light greenish color of the background for the highlight of the eye. Using the background color here will further immerse the owl into the environment.

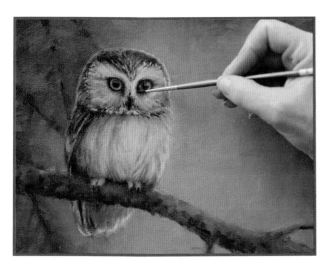

9 Add the Details

Now, with a no. 0 round sable paint the owl's feet using the tree branch mixture. Mix a little Ultramarine Blue and Raw Umber together and use the no. 0 round sable to paint the talons. Suggest light on the top of his toes with a touch of Naples Yellow and Cadmium Orange. Wipe off the no. 0 round sable and add the highlights to the talons with Titanium White and a touch of Ultramarine Blue.

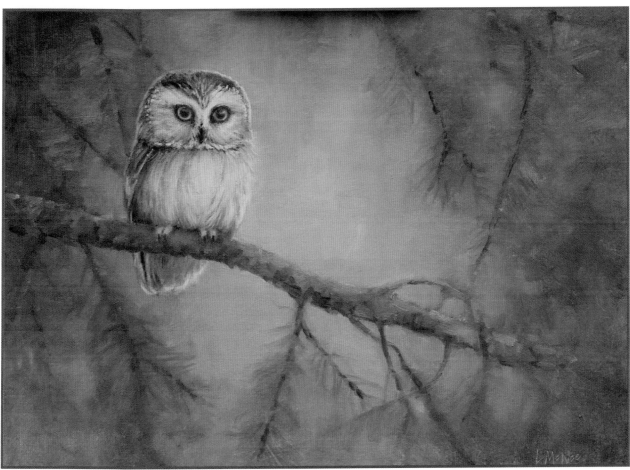

10 Finish Up

Keeping the details simple, add touches of darks to the tree boughs and the owl's tree branch with a no. 2 round and a mix of Ultramarine Blue and Burnt Sienna. Add some loose brushwork to the branch for texture with a few lighter notes to the top of the branches to suggest light, using a no. 2 round and a mixture of Naples Yellow and Cadmium Orange. With a no. 8 flat, apply a very thin glaze of Cadmium Yellow Light with glazing medium over the upper green boughs to further enhance the feeling of light.

Backyard Visitor—Saw-Whet Owl
Lori McNee
Oil on Arches Oil Paper mounted on board
12" × 16" (30cm × 41cm)

Create Magical Color With Atmosphere and Value

I spend a lot of my time outdoors, so for my demo I wanted to capture an everyday scene with a little magic. This woodpile was in a friend's backyard, and I was fascinated by the way the light played off the logs. Inspired, I decided to add one of my favorite subjects to the painting, a pair of young owls. But, as you will see, the subject eventually changed.

MATERIALS

Support
Jack Richeson gessoed hardboard, Ampersand gessoboard

Belgium linen

Acrylic Paints
Alizarin Crimson, Burnt Sienna, Burnt Umber, Cadmium Red, Cadmium Yellow, Naples Yellow, Payne's Gray, Raw Sienna, Raw Umber (opaque), Raw Umber (transparent), Sap Green, Transparent Viridian Hue, Ultramarine Blue, Yellow Ochre

Brushes
¼-inch (6mm), ½-inch (13mm), 1-inch (25mm) flat rakes

Nos. 1, 2 rounds

Nos. 10, 12 flats

Other Supplies
Gray paper palette, palette knife, sketchbook, toothbrush, vine charcoal, white gesso

1 Tone the Panel and Sketch the Composition
Start with a mid-gray gessoed panel. A mid-tone panel gives you the ability to see the values right off the bat. You can establish your darkest dark areas and the lightest areas without struggling with a white background. Use vine charcoal to sketch the composition of the logs and the owls.

2 Establish the Lights and Start to Block In
Using a ½-inch (13mm) flat rake, establish the lights using a light gesso and Cadmium Yellow wash. Any flat would work, but the size of the brush depends upon the size of the painting.

Start to block in the logs and the owlets with a ½-inch (13mm) flat rake and Raw Umber, Payne's Gray and white gesso. Block in some background color to make sure the values are set.

3 Add the Darks
Add darker values to the foreground with a dark mix made with equal parts Ultramarine Blue, Burnt Umber and Payne's Gray, and a ¼-inch (6mm) flat rake. Add more detail to the logs.

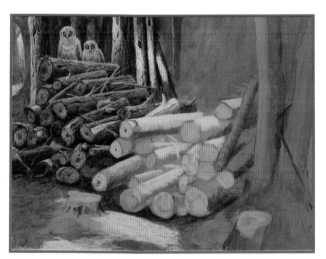

4 Add More Detail and Lights
Continually add detail to the logs and a little light to the background. Use a no. 10 flat and mainly Raw Umber, Raw Sienna, Payne's Gray and white gesso.

Artist Profile:
Suzie Seerey-Lester

Like the Florida sunshine, wildlife artist Suzie Seerey-Lester's warmth radiates through her smile and heartfelt paintings. I met Suzie years ago, while exhibiting with both Suzie and her artist husband, John Seerey-Lester, at a gallery event in Jackson Hole, Wyoming. Since then, it has been great staying connected through Facebook.

Suzie took her first art class in 1990. Back then she traveled the world while working for an international courier company and before that as a diving instructor to the CIA, U.S. Secret Service, U.S. Marshals Service, FBI and other law enforcement personnel. Nowadays, Suzie concentrates on art as a professional and paints mainly North American mammals and birds, as well as African subjects, but her real passion is old barns and historic buildings.

Suzie is a member of the Society of Animal Artists and has won several distinguished awards. Her works have also been exhibited at Birds in Art at Leigh Yawkey Woodson Art Museum in Wausau, Wisconsin.

Suzie and John married in January 2000. Their happy union has created the power couple of the wildlife art world! They live together, paint together and play together in Florida.

seerey-lester.com

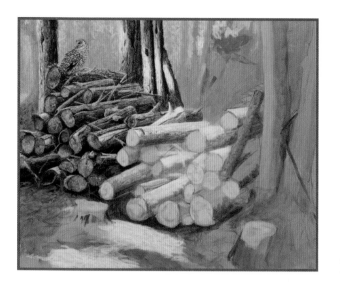

5 Paint the Background and Then Change the Composition

The "magic color" appears in the background. This is a combination of Transparent Viridian Hue and Alizarin Crimson. Mix the two colors to create a wonderful rich gray, then add white gesso to make the value you want.

You can now take whatever color you want to use in the background (we'll use Yellow Ochre), add it to the magic color, and it will gray off the yellow without turning it green. It creates a cool background color and just the right values! Still using a ½-inch (13mm) flat rake, work your "magic" in the background.

I felt the composition did not work with the owlets and replaced them with an adult barred owl. Using a no. 10 or 12 flat, apply the mid-gray gesso to erase the owlets. Allow the gesso to dry, then use a no. 1 or 2 round to paint the adult owl with Raw Umber, Burnt Umber, Payne's Gray and white gesso. The adult owl helps the viewer to see the scale of the log pile. It is okay to change your painting at any time if you are not happy with it. I chose to have the owl looking out of the painting to take the viewer's eye through the painting.

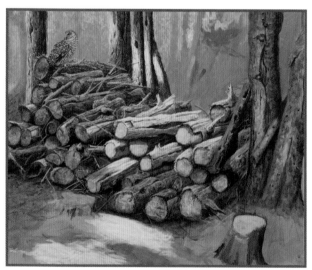

6 Add More Details

Add more detail to the logs and trees. Keep the logs lighter where the light is hitting and the logs in shadow a little darker. For the lighter areas use white gesso and Cadmium Yellow. For the darker areas use the dark mix from Step 3. Continuing painting with ¼-inch (6mm) and ½-inch (13mm) flat rakes.

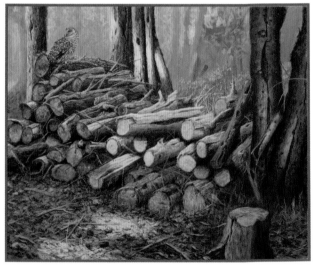

7 Develop the Foreground

Create the foreground with thin washes of Burnt Sienna and Raw Umber, using a 1-inch (25mm) flat rake over the elements on the ground.

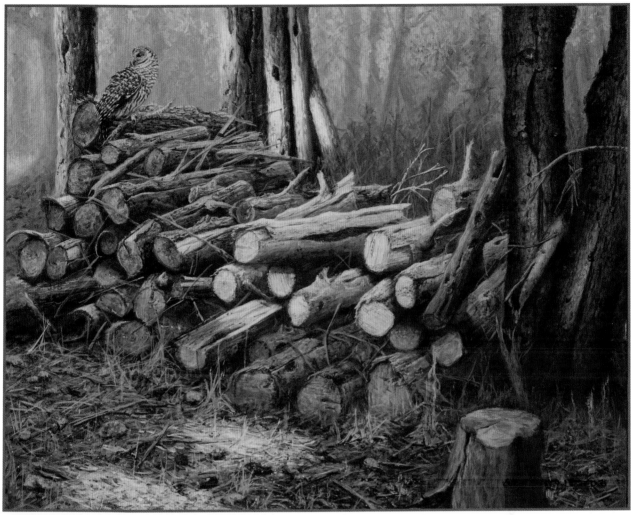

8 Add the Finishing Touches

I removed the midground bush that was initially indicated and replaced it with saplings. Using the ¼-inch (6mm) flat rake, apply the magic color from Step 5 with Sap Green and Raw Umber. Complete the background, keeping it cool and light.

Morning Light—Barred Owl
Suzie Seerey-Lester
Acrylic on gessoed board
16" × 20" (41cm × 51cm)

Suzie's Fine Art Tips

- Uneven numbers of things are more pleasing to the eye than even numbers.
- Paint your warmest, darkest darks in the foreground and your coolest light darks in the background. This gives the illusion of space. Remember: warm colors come forward, cool colors recede.

Storytelling Through Paint

My paintings tell a story. I love historic hunt scenes, and I've published two books that are filled with over two hundred paintings and one hundred true stories. "Breached" is one of the stories from *Campfire Tales*. This painting is about a honeymooning couple who have their dog with them in Africa. The leopard wants the dog, and in the end the dog wins.

MATERIALS

Support
Ampersand Gessobord

Acrylic Paints
Burnt Sienna, Burnt Umber, Cadmium Red, Cadmium Yellow, Naples Yellow, Payne's Gray, Raw Sienna, Raw Umber, Ultramarine Blue, Yellow Ochre

Oil Paints
Burnt Sienna, Burnt Umber, Cadmium Red, Cadmium Yellow, Naples Yellow, Payne's Gray, Raw Sienna, Raw Umber, Titanium White, Ultramarine Blue, Yellow Ochre

Brushes
Nos. 2, 4, 6, 8, 10, 12 flats

½-inch (13mm), ¾-inch (19mm), 1-inch (25mm) rakes

Grumbacher Series 4623, no. 2

Goldenedge, no. 00

Other Supplies
Alkyd medium, black permanent pen, palette knife, paper palette, sketchbook, toothbrush, vine charcoal, white gesso

1 Begin With the Concept
Using a black permanent ink pen on sketchbook paper, use sketches to conceptualize your paintings. Do ten or fifteen thumbnail sketches to develop the idea and composition of the painting.

2 Sketch the Design
With a mid-gray toned panel, use vine charcoal to sketch the bed and the tent. You can purchase a pre-toned panel or tone one yourself with a mixture of white gesso and a bit of acrylic Ultramarine Blue and Burnt Umber. You can see the initial sketch of the leopard with his head in the tent.

3 Block In the Leopard With Acrylic
Now that the design is established, start to block in the leopard. Use a 1-inch (25mm) rake and Raw Umber, Payne's Gray and Naples Yellow acrylic paint. I use props as a reference to create my paintings. It's a good idea to have pots, pans, bottles, bags, books, crates and costumes in the studio to use at any time.

Artist Profile:
John Seerey-Lester

Among wildlife art enthusiasts, John Seerey-Lester has garnered rock star status. I first met John over twenty years ago while attending one of his respected master classes. I remember what a thrill it was to watch the master at work, both in the field and in the classroom.

John's renowned paintings have a mysterious and mystical appeal that directly relate to his ability to portray the unusual. His artwork is regarded and recognized worldwide for his depiction of large mammals and birds of prey.

Originally from Manchester, England, John was born with a sketchbook in hand. After his first visit to east Africa in 1980, John began painting wildlife images. In 1982, John moved to the United States and since has published over three hundred limited-edition prints and books. John has received many awards and much recognition for his outstanding achievements in the field of wildlife art. Prince Philip commended John for his work in conservation, and Archduke Andreas of Austria knighted him!

I credit John for teaching me how to paint realistic animal fur, feathers and eyes. John's patient demeanor and British humor helped make an unintimidating learning environment.

Years later, it has been my pleasure to reconnect with John through Facebook. But, it was even more exciting to have my paintings hang alongside John's at a gallery exhibit. To have John and his lovely wife Suzie in my book is to have come full circle.

seerey-lester.com

4 Paint the Light

Once the acrylic underpainting is dry, it is time to switch to oils for the overpainting. Begin establishing the glow from the lantern to set the stage. Paint the glow using Cadmium Yellow, Cadmium Red and a touch of Titanium White and a variety of flats.

Using nos. 4–8 flats, mix a few thin puddles with a combination of Burnt Umber, Burnt Sienna, Ultramarine Blue and Titanium White, indicate the rug, and then include a bag, a crate and the honeymoon couple's German shepherd under the cot. The final touch is a scumble of Cadmium Yellow and Burnt Sienna around the light.

5 Add the Shadows

Now add the shadows to the tent. It is important to understand how light from the lantern moves to create the correct shadow. In this case, the binoculars cast a shadow on the tent, the soda siphon on the pillow and the leopard on the back of the flap. The rug is changed to a skin, which makes the scene more interesting and authentic.

Use a no. 6 or 8 flat and the same paint mixture from Step 4 with some Cadmium Yellow added to enhance the yellow atmosphere that is created by the glow of the lantern. For this step use a no. 6 or 8 flat.

6 Add the Finishing Touches

Add the stripe pattern to the zebra skin rug and the trunk details with a no. 10 or 12 flat and Burnt Umber and Ultramarine Blue for the darkest darks. Add a glaze using Payne's Gray and Raw Umber to pull the shadow area together.

What started out as an acrylic is now an oil painting.

Breached
John Seerey-Lester
Oil on panel
20" × 30" (51cm × 76cm)

Lori's Art Business Tip

John's art business exemplifies a favorite quote of mine by marketing expert Seth Godin: "Marketing is no longer about the stuff that you make, but about the stories you tell." Interesting stories help sell art!

Portraits and Figures

4

When strolling around an art museum or portrait gallery, I often feel humbled and curious. I ask myself, "How did the artist do that?" I know I am not alone with this question.

The human face is the most memorized, commonplace object that we see on a daily basis. For this reason, people as a subject are challenging to paint. Even the non-artist can detect the slightest flaw in the construction of the human face or body. One misplaced brushstroke can cause your model to suddenly look inaccurate.

Rendering the human form in any medium requires experience with proportions and scale and knowledge of anatomy. It is vital for the artist to understand the concepts of tone, color mixing, soft and hard edges, and draftsmanship while at the same time being able to portray the inner essence of the model.

There are nuances between portraiture and figurative works. Generally speaking, figurative works are those that use the human form to tell a story. A figurative painting most often has the model engaged in an environment, or interacting with props or other people. Portraits quite often have the model engaged with the viewer, or at least the model's face is the center of interest. Figurative work tends to have a broader appeal to the unknown collector, whereas a specific client most often commissions portraits, though there are exceptions.

Whether working from a photograph or from a live model, a well-executed portrait or figurative painting must demonstrate the illusion of life. The following demonstrations of professional portrait and figurative works will help you demystify the process of painting the human form.

Summer in Venice
Steven Rosati
Oil on linen
24" × 18" (61cm × 46cm)

Portraits and Figures Inspiration

Through the centuries, the greatest artists have been inspired by others, including the Old Masters. The following images and demonstrations by some of today's finest portrait and figurative painters are sure to spark your creativity!

Sherry
Daniel Sprick
Oil on panel
20" × 20" (51cm × 51cm)

Kenton
Daniel Sprick
Oil on panel
20" × 16" (51cm × 41cm)

Dr. Trevor W. Payne
Steven Rosati
Oil on panel
36" × 36" (91cm × 91cm)

Our Song Don't Bring You Home Anymore
David Goatley
Oil on linen
30" × 30" (76cm × 76cm)

Addie
David Gray
Oil on panel
9" × 12" (23cm × 30cm)

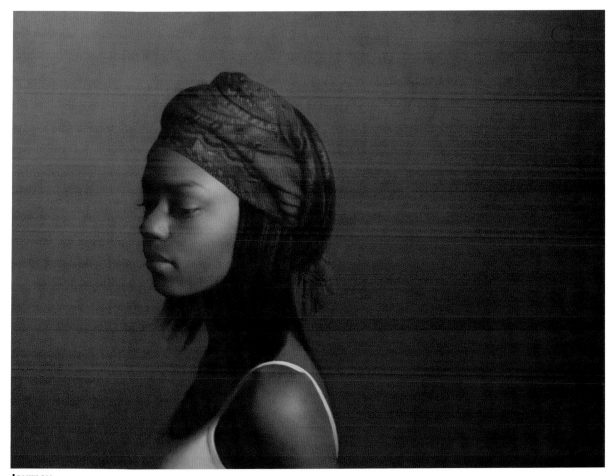

Journey
David Gray
Oil on panel
18" × 24" (46cm × 61cm)

Head Proportions and Measuring Made Easy

There are more than six billion of us jostling for space on this planet, in every size, shape and color. Each of us different, yet each surprisingly the same.

The identical basic proportions apply to each and every face, which makes beginning a portrait a little easier. However, the tiny differences that make us all unique are a real test of observation and practice.

Remember these basic rules and alignments and you will have an accurate foundation to build upon, a system of measure to keep the face in proper proportion. I've used these quick sketches of my son, Ryder, to show you how a face fits together.

MATERIALS

Support
Oil-primed linen panels

Oil Paints
Burnt Sienna, Cadmium Orange, Cadmium Red Light, Cadmium Yellow Pale, Cerulean Blue, Ivory Black, Naples Yellow, Permanent Rose, Raw Umber, Terra Rosa, Titanium White, Ultramarine Blue, Viridian Green, Yellow Ochre

Brushes
Nos. 1, 2, 4, 6, 10 brights

Other Supplies
Alkyd medium

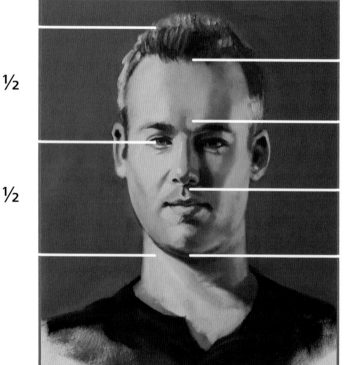

½ ½ ⅓ ⅓ ⅓

Figure 1: Horizontal Alignments

- The eyes are halfway between the top of the head and the chin.
- The distance from the hairline to the eyebrow, the eyebrow to the bottom of the nose, and the bottom of the nose to the chin are the same. This divides the face below the hairline into thirds.
- The underside of the lower lip is halfway between the nose and chin.
- The top of the ear is roughly in line with the eyebrow. The earlobe approximately aligns with the bottom of the nose. Keep in mind, our ears go on growing, and therefore ears of older people are often larger than this.

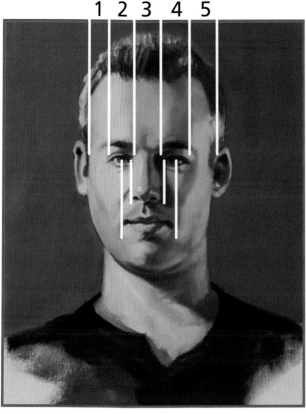

1 2 3 4 5

Figure 2: Vertical Alignments
- Both eyes are the same width, with the width of a third eye between them.
- The distance from the outer corner of the eye to the outside edge of the head is roughly equal to the width of the eye. This makes the head five "eyes" wide.
- Looking straight ahead, the pupils and the outer corners of the mouth are the same width.
- The tear duct and outside edge of the nose fall roughly into line.

David's Fine Art Tips

- It is the tiny variations in facial alignments that add up to the differences between us.
- Note, my son's mouth is quite narrow. Most people's mouths are a little wider, lining up with the pupil of the eye. This is a good example of using these measuring guidelines as a rule of thumb, rather as being set in stone.
- Most artists use photographs in at least part of their process, but do work from life whenever you can.

Artist Profile: David Goatley

David Goatley believes we each have a story that demands to be told. Much of that story is written in our faces. This is the reason why David became a portrait painter.

Born in London, England, David trained at the Camberwell College of Arts. Years later, David is recognized as one of North America's leading portrait painters. He fulfills commissions across Canada, the U.S. and the U.K. and has painted nearly four hundred commissioned portraits, including royalty, political, business, corporate and academic leaders, and many private families.

I first met David years ago when he conducted a workshop in my hometown. David's extensive knowledge of painting and anatomy, together with his relaxed nature, make him a popular instructor.

Later, I commissioned David to paint my three children. And, true to his nature, David painted a portrait of me as a gift in return! We enjoy staying in touch through Facebook.

It is my pleasure to share David's helpful measuring system for portrait painting with you.

davidgoatley.com

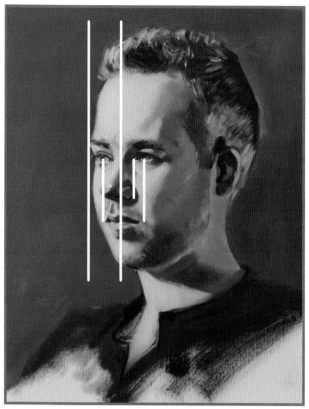

½ **½**

Figure 3: Partial Profile Alignments

Everything still lines up the same way vertically and horizontally. The same is true when a head is tilted (see Figure 5) except that the alignments follow the angle of the tilt.

- A partial profile is often called a three-quarter view, although it is closer to four-fifths. The far side of the mouth will appear smaller than the near side.
- The far eye seems compressed into a narrower space. It is partially obscured by the nose and so on. Everything still lines up the same way vertically and horizontally.
- The same is true when a head is tilted except that the alignments follow the angle of the tilt.
- Again, my son's mouth is quite narrow. Most people's mouths are a little wider, lining up with the pupil of the eye.

Figure 4: Full Profile Alignments

- The ear canal is halfway between the front and the back of the head.
- The distance from the corner of the eye to the jaw is roughly the same as the distance from the corner of the eye to the back of the ear.
- Drop a line from the outer edge of the eye socket and it usually lines up with where the neck begins to slope away from the jaw.
- Remember, a person's neck is not on top of his shoulders, but set into them. The neck ends at the collarbone, below the shoulder line.

David's Fine Art Tip

These rules work for anyone over the age of twelve, when our heads attain their adult proportions. Younger children's faces are smaller with more closely grouped features, the upper part of the head being proportionally larger.

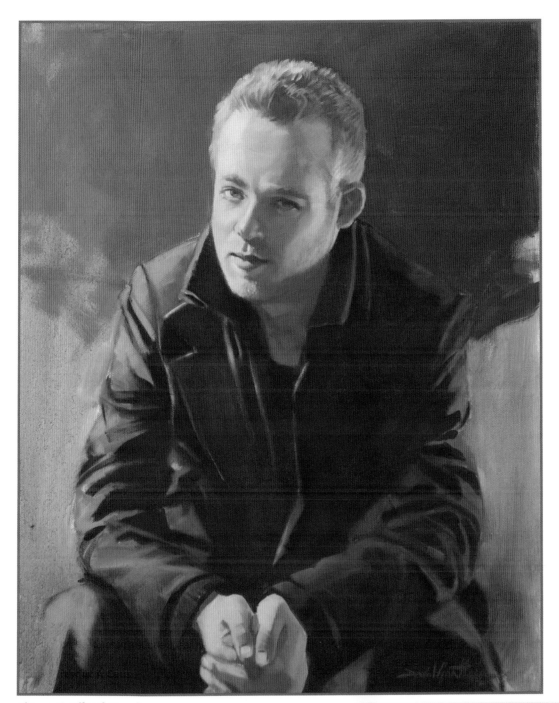

Figure 5: Tilted Head

Finally, this color sketch illustrates the tilt of the head where the alignments and proportions still work. Notice how you can see a little more of the top of the head, which brings the eyes slightly below the halfway mark. This slightly compresses all the spacing between the features in a subtle linear perspective.

Rebel Without A Cause
David Goatley
Oil on canvas
20" × 16" (51cm × 41cm)

David's Art Business Tip

A career in painting is like any career: You need good, solid work habits. I'm at the easel by 10 A.M. and work through until 6 P.M. with a break for lunch. I will often work an additional hour or two in the evenings.

Steps to Creating a Classical Portrait

When teaching, I am amazed by how quickly and inaccurately the students lay down the paint. If you want to be a realist, you must train yourself to slow down. I am an advocate of comparative measuring with some sort of measuring tool such as a knitting needle. Make marks that are sure and accurate, and double-check and triple-check your measurements before moving onto the next one.

MATERIALS

Support
9" × 12" (23cm × 30cm) panel

Oil Paints
Cadmium Orange, Cadmium Red Light, Cadmium Yellow, Ivory Black, Phthalo Green, Quinacridone Violet, Raw Umber, Terra Rosa, Titanium White, Transparent Red Oxide, Ultramarine Blue, Yellow Ochre

Brushes
Nos. 0–10 filberts
Assorted soft rounds
1-inch (25mm) fan

Other Supplies
Alkyd medium, foam makeup applicator, mineral spirits, vine charcoal, walnut oil

1 Create the Underdrawing
Using vine charcoal of a medium hardness, first do a very rough block-in to establish basic placement of the model on the canvas.

With comparative measuring, mark out some basic vertical proportional relationships on the canvas. This will achieve the accurate distances between the top of the head, top of the eyebrows, bottom of the nose and bottom of the chin.

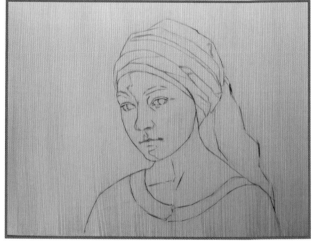

2 Complete the Block-In
The block-in must comply with the measurements on the canvas. It is important to try to see the big shapes. Dust the block-in with a 1-inch (25mm) fan. I call this "ghosting" the image. The point is to partially erase the first block-in underdrawing while not obliterating it completely. It will be a faint image.

At this stage, do a second pass with a sharpened vine charcoal stick. Really try to get it right, still looking first at the larger shape relationships. Once established, accurately lay in the smaller forms, such as features and fabric folds.

Now, reinstate this underdrawing with Raw Umber. Simply trace the ghosted charcoal image, taking the opportunity to correct any minor inaccuracies.

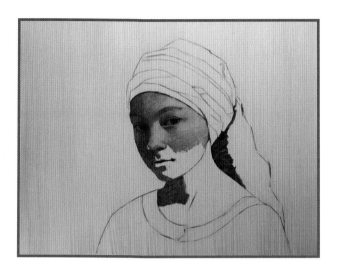

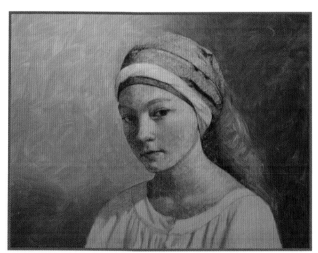

3 Start the Underpainting

With nos. 4 and 6 filberts, lay in the basic color scheme with oil paint thinned with mineral spirits. I use an "open palette" system, which means I tap into whatever color is needed at the time. This makes it difficult to explain exact color recipes. For this painting, I used all the colors from my palette. Get to know your palette so you can mix what you see. Add in a little alkyd medium to facilitate drying. Use a color underpainting as opposed to a gray or umber grisaille because you can begin to see the color relationships reveal themselves.

For the background, use a no. 8 or 10 filbert and mix Raw Umber and Titanium White with a touch of Yellow Ochre and Transparent Red Oxide in the shadows. Use the background color to shade the creases and folds for the white blouse.

This underpainting step is of great help in getting adequate coverage in the next step. Cover the entire painting and let dry.

Artist Profile: David Gray

David Gray's elegant still-life and figurative paintings harken back to the Neoclassical era, which drew inspiration from ancient Greece and Rome. Each of his paintings is a contemporary expression of beauty and order with a deep respect for classical tradition.

David's still life and figurative works are equally celebrated for their quiet tones, sophistication and minimalistic designs. The first time I saw a David Gray painting it struck a chord within me. Much like a haiku, there is a poetic rhythm that emanates from his paintings.

David has always had an affinity for the figure. His figurative works summon the viewer into calm contemplation. These soothing portraits usually focus upon the head and shoulders of his subject, many of whom are his own children and wife.

David began studying physical therapy and anatomy before switching majors to art. David earned a B.F.A. from Pacific Lutheran University in Tacoma, Washington, and today continues to challenge himself as an artist with independent formal studies.

David has received many national awards and features in major art publications for both his still life and figurative works. David is also a talented teacher. It is special to have my fellow artist and Facebook friend share his extensive knowledge with us.

davidgrayart.com

4 Start the Overpainting

With the no. 4 filbert, begin the overpainting with the forehead and eye region of the head. Begin by keying the area for color and value. Lay in some dark tiles or brushstrokes in the darker parts of the painting. Normally some of the darker areas of the head will be in the eyes.

Using these darkest darks as one side of the value scale, continue to place other tiles in the general area for the lightest lights and some middle value tones. Place about seven to nine tiles in the general area, trying hard to relate both their values and colors appropriately. Instead of trying to neatly blend the color from the beginning, lay in separate broken brushstrokes. The initial effect is somewhat like a paint-by-number project.

The process of overpainting involves a region-by-region or "window shading" sequence, finishing a localized area before moving on to adjacent sections of the painting. Use larger brushes for the bigger passages, and smaller brushes for details.

5 Blend the Tiles

Now, blend the tiles together using a dry no. 4 filbert. Very gently push and pull the edges of the tiles together until they are blended, making sure the forms are turning.

Sometimes during the process of blending an area might get muddy. If so, simply restate anything that needs it with additional tiles, and then re-blend as needed.

Continue this tiling and blending procedure with no. 4 and 6 filberts, region by region, until the painting is done. Let dry to the touch.

Tiling Tips

In the larger forms and the background, the tiling/blending process is not so strict. Tile and blend at the same time. But the smaller more detailed areas such as the features and certain folds are better handled in a more disciplined manner, first tiling and then blending.

6 Begin Glazing

Finish the overpainting, and use a glaze as a corrective or enhancement tool. Transparent glazes of Ivory Black with a little Cadmium Red Light or Transparent Red Oxide mixed with alkyd medium help warm up the shadows. Adjust skin tones with glazes as needed.

Once the painting is dry to the touch, the first step in glazing is to "oil out." Using a soft no. 8 filbert, apply a thin layer of medium made with half walnut oil and half mineral spirits. Brush medium onto any areas you plan to work on. Once the medium is brushed on, mop most of it off with a foam makeup applicator. This pulls most of the medium off but leaves just a thin film of oil. This thin film of oil allows for a fluid application of the glazes.

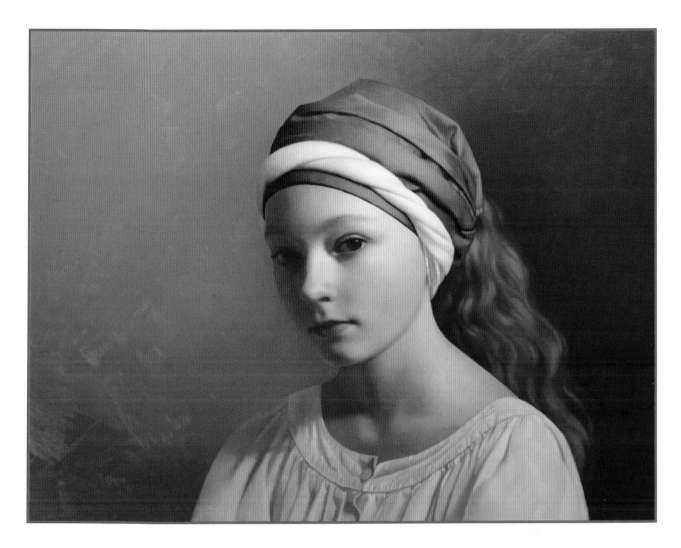

7 Finish Up

Continue with the same glazing process as explained in Step 6. Apply thin coats of transparent and semitransparent color wherever needed. Add a small amount of medium to the glazes to give them a little more body and "stickiness." Use larger brushes for the bigger passages and smaller brushes for the detailed areas. Glazing brings up the value in the lightest tones, darkens shadows, warms up the thin-skinned areas of the face and unifies choppy areas.

Addie
David Gray
Oil on panel
9" × 12" (23cm × 30cm)

David's Fine Art Tip

If you truly want to learn to paint well, you must commit a significant part of your life to it. Count the cost and realize it's a journey without an end. You must carve out easel time and protect that time. Paint as often as you can and don't wait for inspiration. Learning to paint well takes a lot of time and a lot of effort. Many artists, including myself, spend many years learning their craft, selling work in galleries and teaching workshops, and at times still feel like a babe in the woods when it comes to making that next picture. Enjoy the journey.

Monochromatic Underpainting a Portrait

This demonstration of *Julia, Who Was From Russia* emphasizes the monochromatic underpainting of a model in profile. I have taken to this practice occasionally in the last couple of years, as this technique can help establish drawing and values more easily before painting over it in opaque colors.

MATERIALS

Support:
26" × 28" (66cm × 71cm) Baltic birch cabinet-grade hard panel

Alkyd Paints
Raw Umber, Titanium White

Oil Paints
Burnt Sienna, Cadmium Green, Cadmium Red Deep, Cadmium Red Light, Cadmium Yellow Pale, Dioxazine Purple, Ivory Black, Permanent Alizarin Crimson or Quinacridone Rose, Raw Sienna, Raw Umber, Sap Green, Titanium White, Turquoise Blue, Ultramarine Blue, Van Dyke Brown

Brushes
No. 2 liner

Nos. 00, 01, 3, 8, 10 soft synthetic rounds

Nos. 8, 10, bristle brush filberts and flats

2-inch (51mm) starter brush

Soft blender brush

Other Supplies
3¼-inch (83mm) triangular-shaped palette knife, alkyd medium, medium- to coarse-grit sandpaper, mineral spirits, paper towels, vine charcoal

1 Begin the Block-In

With vine charcoal, sketch the drawing. Next use Raw Umber and Titanium White and a no. 2 liner to begin drawing with alkyd paint. Block in the monochrome underpainting with a no. 8 round. The paint here is a quick-drying alkyd formulation. The intention is to get the model blocked in during one day so the underpainting will be dry and ready to paint over by the following day. If it is drying too quickly to blend, mix in 50 percent slow-drying Titanium White.

2 Develop the Monochromatic Underpainting

With a no. 8 round, develop the drawing and values of the underpainting. Keep the values close. I usually aim for two values. Use the texture of thick paints at the high part of the cheek where there will be a light area.

Daniel's Fine Art Tip

The smaller the diameter of the form, the faster it turns and the sharper the edge because there is less room for light to wrap around it. The larger the diameter of the form, the more slowly it turns, so there is more light enveloping the form, which will usually result in a softer edge.

Artist Profile: Daniel Sprick

Daniel Sprick began drawing at age four, though aircraft were his passion. Today, Daniel is both a highly acclaimed artist and an experienced pilot. He relates the exquisite line in art to being airborne. To him, each painting must have just the right launch and must conclude in a perfect landing.

Revered by his fellow artists and critics alike, Daniel has achieved a distinction that few painters reach during their lifetime. He is equally adept at painting still life, landscape and figurative work. His technique is rooted in naturalism, and he is beholden to the painters of the Northern Renaissance and the Dutch Baroque.

Daniel possesses a deep sensitivity and honesty for his subjects. His recent hyper-realistic portrait series captures the model, be it flattering or not. Yet, for all his devotion to realism, Daniel's view is entirely contemporary.

His admiring fans and colleagues are eager to view his latest paintings, whether on display at a museum, gallery or even on Facebook. The keen observer can see that Daniel is mindful of the tensions between opposites: beauty and oddness, interior and exterior, traditional and experimental, literal and imaginative.

Daniel and I have been Facebook friends, but recently we met "in real life" during one of my travels to Denver. He and I spent a fun and informative afternoon talking about art and life. For lunch Daniel prepared me the most colorful, artful salad, putting it together with as much care as one of his magnificent paintings. Daniel expresses his masterful artistry in every aspect of his life.

It is my honor to reveal the painting secrets of this living master in these pages.

danielsprick.com

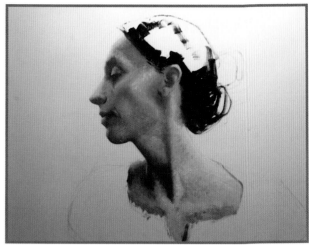

3 Finish the Underpainting

Continue with the Raw Umber and Titanium White mixture and move to block in the model's ear and the back of the head. Try to be accurate, but realize that there will be plenty of correcting to do in the subsequent stages.

Pay attention to the modeling of Julia's graceful neck. Use the values to help create the form. Leave the underpainting more textural than the overpainting.

Criteria of "correct" and "incorrect" don't quite apply, except in the creaky cavern of the mind of the artist. It is where we move it to something we hope will be more expressive, more alive, maybe more interesting.

The monochrome underpainting is in place after the first day of work.

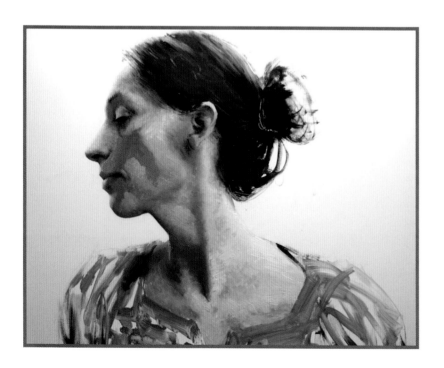

4 Start the Overpainting

Refine the underpainting before moving to the overpainting. Applying texture was enjoyable, but I realize that I have put down more of it than is really needed for this subject. A medium-grit sandpaper easily knocks down some of the texture. Also, use a triangular palette knife to smooth the texture.

Begin painting over the underpainting with opaque oil paint color. The monochrome can be done in about a day, but the actual work of painting over it with color will take some weeks.

Work on correcting the drawing defects. For this step use Titanium White, Cadmium Yellow Pale, Burnt Sienna, Raw Umber and alkyd medium with a no. 3 round.

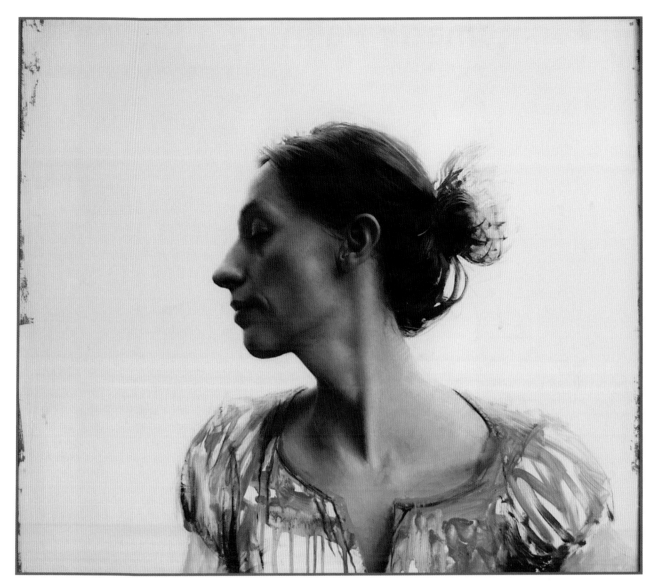

5 Unify the Painting

There are no significant compositional changes in this step, just an effort to imbue it with a subtle harmony. By exaggerating, build a value on the back of the neck that will join seamlessly into the warm white background. Use the background color made of Titanium White and a bit of Cadmium Yellow Pale. If the paint is still pliable, use a soft blender brush to unify the neck with the background. If the paint has become dry, use a bristle brush to move the paint.

The exaggerated brightness on the back of the neck helps to unify the background with the subject, Julia. Take all the edges into consideration, as to how they may unify the subject with the background. I chose to completely diminish the lightest edges in order to integrate the flesh colors with the warm off-white environment.

Notice that the lost edges along the forehead, lower lip, chin and nose are like the effects naturalist painters were creating in the nineteenth century. By diminishing barriers, the various parts of the painting join each other, unifying the piece. The disappearing edges seem to make the remaining sharp ones stronger than they would be had all the edges remained the same.

Julia, Who Was From Russia
Daniel Sprick
Oil on board
26" × 28" (66cm × 71cm)

Monochromatic Painting a Figure

Monochrome drawing, as with *Figure in Snow*, may be the most rapid gratification in painting. It's when the whole composition emerges. There is an immediate sense of scale and proportion.

MATERIALS

Support:
60" × 30" (152cm × 76cm) Baltic birch cabinet grade hard panel

Oil Paints
Burnt Sienna, Cadmium Green, Cadmium Red Deep, Cadmium Red Light, Cadmium Yellow Pale, Dioxazine Purple, Ivory Black, Permanent Alizarin Crimson or Quinacridone Rose, Raw Sienna, Raw Umber, Sap Green, Titanium White, Turquoise Blue, Ultramarine Blue, Van Dyke Brown

Brushes
No. 2 liner

Nos. 00, 01, 3, 8, 10 soft synthetic rounds

Nos. 8, 10, bristle brush filberts and flats

2-inch (51mm) starter brush

Other Supplies
3¼-inch (83mm) triangular-shaped palette knife, alkyd medium, medium- to coarse-grit sandpaper, mineral spirits, paper towels, vine charcoal

1 Start the Monochrome Drawing

Start with a gray primed board, and begin a monochrome drawing in oil paint using Van Dyke Brown and a no. 8 round.

Continue developing the monochrome drawing with Van Dyke Brown. If it seems right, proceed with painting. If there are problems, now is the time to wipe it off with a paper towel and start over. In this case, with the figure low in the picture plane and off center, it seemed interesting enough to develop.

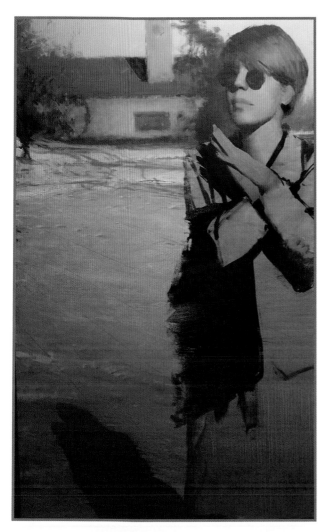

2 Start the Block-In
Working from back to front facilitates a layering of reality. Begin painting the landscape behind the figure.

For the upper sky use Titanium White, Turquoise Blue and a bit of Van Dyke Brown to neutralize the color. As the sky gets lower, it gets warmer. Use Ultramarine Blue, Burnt Sienna and Titanium White. Paint the trees with Cadmium Yellow Pale, Ivory Black and Titanium White.

The warm building color is made of Raw Sienna, Titanium White and Van Dyke Brown. Paint the roof of the building with Burnt Sienna, Titanium White and Cadmium Yellow Pale.

Now that the landscape is fairly finished behind the loosely blocked-in figure, start working on the face and hands. At this point the painting is going well.

3 Refine the Composition
The placement of the figure in the landscape is interesting, but, as the work goes on, there seems to be too equal an emphasis on the figure and the landscape. So I tried out the idea of placing the figure into shadow, thinking that it would make it all more effective.

To paint believable snow, understand the brightest light is perpendicular to the light source. For instance, the ridges of snow in the background behind the figure and the footsteps are the brightest. Premix piles of values and color on your palette. Work from the lightest down to the bluest snow in the foreground. The snow color is the same as the sky. Use Titanium White and Cadmium Yellow Pale for the brightest brights.

Daniel's Fine Art Tip

The time spent premixing at the beginning of a painting saves you time in the long run!

4 Start Glazing

I started glazing the figure into a dark bluish black shadow made with Ultramarine Blue and Van Dyke Brown. But, I am already rejecting it. So, I wiped it off before it had time to dry.

5 Deconstruct the Painting

The finish work in the landscape was annoying, so I attacked it with alkyd medium and coarse sandpaper. Next, I darkened the entire distance and sky with the same bluish black glaze from Step 4, using a 2-inch (51mm) starter brush (you can find these in a hardware store).

6 Finish Up

It's been about two months now since the start. Now, it's time to finish up with the herringbone pattern on the coat and the scarf. The coat gets some deep black holes in the shadow parts, which helps to make for a strong sense of space, or the illusion of distance. Glazing the lower part of the coat helps create the illusion of distance. For this glaze use a 2-inch (51mm) starter brush and Ivory Black mixed with 50 percent alkyd medium and 50 percent mineral spirits.

Figure in Snow
Daniel Sprick
Oil on panel
60" × 30" (152cm × 76cm)

Daniel's Fine Art Tip

Use Ivory Black to neutralize darker sections and Titanium White to neutralize lighter sections. Ivory Black is preferable for glazing because Mars Black has too strong a tinting strength and is very opaque.

Portrait Painting Secrets of the Old Masters

A great way to sharpen your painting skills and recharge your artistic soul is to copy an Old Master work. There you will find all their secrets. If you are lucky to copy a masterwork directly from a museum, you will see the exact colors, layers and shades the Old Master used. If not, you will have to find the best and highest quality image on the Internet or from a poster or book.

For my demonstration of Leonardo da Vinci's *Lady With an Ermine*, I am using my portrait palette system, which has all the colors needed not only for this, but also for any portrait (see sidebar with mixes on page 138). This demo is my own technique that I have developed from many Old Master influences.

My surface is acrylic-primed linen, which I then gesso and glue to a hardboard panel. Don't sand the last layer of gesso. This gives the paint some tooth to hang onto.

MATERIALS

Support
Acrylic-primed linen

Oil Paints
Burnt Umber, Cadmium Red Light, Cadmium Red Medium, Cadmium Yellow Lemon, Ivory Black, Titanium White, Ultramarine Blue, Yellow Ochre

Brushes
Nos. 1, 2, 3, 4, 5, 6, 16 soft bristle flats
Nos. 1, 2, 3, 4, 5, 6 soft bristle filberts

Other Supplies
Burnishing tool, charcoal, Cobra glazing medium, Cobra painting medium, pencils (H–4B, 6B), spray retouch varnish, tape, white glue

1 Print the Image
Because the complete image was much bigger than my 8½" × 11" (22cm × 28cm) printer, I had to print three separate images to create the whole figure. Overlap each print to get the correct alignment and tape the sheets together.

In Adobe Photoshop, remove the dark background to save ink.

2 Prepare for Transfer
Flip the image around and shade only the areas that you need to transfer with a 6B pencil or charcoal.

Place the flipped image against a window so you can see where to shade. Once that is done, flip back the sheet and carefully center and tape the print onto the canvas to prevent it from shifting.

3 Start the Drawing

This is the most important step. Trace the lines onto the canvas with a burnishing tool (or use a dull pencil or a dried-out pen). Take good care in drawing and modeling the face and figure as accurately as you can, as this will be your underpainting. I used a range of pencils from H to 4B. Spray a very light mist of retouch varnish to seal the drawing. Let dry.

4 Tone the Drawing

Next, use a no. 16 flat to apply a transparent Yellow Ochre water-mixable oil wash thinned with very little water to unify and tone the painting. This will be the only time I will use water as a thinner. The wash gives a pleasing gray underpainting, ready for the flesh color.

Artist Profile: Steven Rosati

Award-winning portrait artist Steven Rosati is nationally recognized for his unique style and technique, which derives from the traditions of the European Old Masters. Although he studied art in schools, Steven considers his most influential mentors to be the likes of Leonardo, Van Eyck, Van der Weyden and Bouguereau. Over the years, he has spent countless hours in museums observing treasured works by these masters.

Steven's portrait paintings evoke his model's likeness, soul and unique beauty. Recently, I had the pleasure of watching Steven in action. Within moments he truthfully grasped the likeness of his model on canvas, much to the delight of onlookers.

Steven is equally adept at working in the studio or painting out in the field near and around Montreal, where he lives with his wife and children.

He is a member of the Portrait Society of Canada and the Portrait Society of America and has garnered many awards, magazine covers and achievements, yet Steven remains humble. He has a natural way of putting people at ease, and it's not surprising that many dignitaries, professors, business professionals, celebrities and sports stars have entrusted him with capturing their likeness in paint.

Steven and I work together as art ambassadors for Canson and Royal Talens. I am grateful Steven agreed to share his years of classical knowledge, which he condensed down into this fabulous demo.

stevenrosati.com

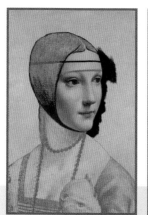

5 Paint the First Layer

With nos. 1 and 2 filberts, use my limited portrait color palette system and begin painting the head following the values of the underdrawing and the image. I'm using 50 percent water with 50 percent Cobra painting medium at this early stage.

It's a good idea to paint some of the background color so you can make better flesh color decisions. Soften all edges where the background meets the face and body.

Steven Rosati's Portrait Palette System

The unadulterated hues are along the top edge of the palette. These hues are mixed with each other and increasing amounts of Titanium White as you work your way toward the bottom of the palette. Use the guidelines and numbered labels for the exact ratios.

- The Cadmium Red and Cadmium Yellow Lemon row is for the lighter values of the face.

- The Cadmium Red Medium and Yellow Ochre row is for the medium values.

- The Cadmium Red-Burnt Umber-Black row is for midtones and darker values.

- The Burnt Umber-Black-Ultramarine Blue row is the cool color values. This row is used to cool down the warm flesh mixes.

- When cooling down a color mix you must be sure to choose the same value for both the warm mix and cool mix.

- The first row is the cool dark to cool gray row.

- The second row is the warm dark to warm gray row.

- The third row is the medium flesh to light medium flesh row.

- The fourth row is the light flesh row.

#	Color
1	Ultramarine Blue
2	2 parts Burnt Umber 1 part Ivory Black 1 part Ultramarine Blue
3	1 part mix 1 part Titanium White
4	1 part mix 1 part Titanium White
5	Ivory Black
6	Burnt Umber
7	2 parts Burnt Umber 1 part Ivory Black 1 part Cadmium Red Medium
8	1 part mix 1 part Titanium White
9	1 part mix 1 part Titanium White
10	Cadmium Red Medium
11	Yellow Ochre
12	1 part Cadmium Red Medium 2 parts Yellow Ochre
13	1 part mix 1 part Titanium White
14	1 part mix 1 part Titanium White
15	Cadmium Red Light
16	Cadmium Yellow Lemon
17	1 part Cadmium Red Medium 2 parts Cadmium Yellow Lemon
18	1 part mix 1 part Titanium White
19	1 part mix 1 part Titanium White
20	Titanium White

6 Continue Painting and Glazing

By this stage you should have completed at least three layers of color on the face to build a solid form. Each layer consists of less water mixture in your medium mixture. This follows the fat over lean rule.

Always pay close attention and follow your underpainting values (light, mids and darks) when you are applying color. Use nos. 1 and 2 filberts and flats for this step.

Spread the glazing medium on the area to be painted to wet the surface.

7 Finish Painting and Glazing

Wet the work area with a little Cobra glazing medium and a no. 6 flat. This is the time to paint any final glazes or highlights, to deepen or brighten colors while always comparing it to the photo reference.

Again, use the nos. 1 and 2 filberts and flats for the face. Make sure your brushes are soft and have a good soft spring to them. Use the larger brushes for the clothing and background.

Avoid trying to match the colors that have faded through time that are in your photo reference. Paint your own copy the way Leonardo might have painted it today!

Lady With an Ermine After Leonardo da Vinci
Steven Rosati
Oil on linen
21" × 15" (53cm × 38cm)

Steven's Fine Art Tip

After the painting has dried for six months I spray it with Cobra varnish to give it a pleasant shine and protection.

Art Business Tips

Developing your business skills is an important part of being a professional artist. Here are some of my best tips for writing an artist's bio and artist's statement and for using social media to market your work. Go to artistsnetwork.com/fine-art-tips-lori-mcnee for additional business tips, templates and resources.

Lori's Tips for Writing an Artist's Statement

The artist's statement is a short piece, about three paragraphs or fewer. It answers questions your viewers may have about you and your art. The artist's statement is a vital marketing tool used to promote you and your artwork to potential buyers, critics, fellow artists, friends and exhibition curators. It should be informative and add to the understanding of the artist in an easy, concise manner.

Use the informal first person, "I" or "me" for website or blogging and the formal third person "name" or "he/she" for exhibition, grant and gallery use. Consider your audience. You might have two or three versions that you use.

Lori's Tips for Writing an Artist's Bio

Your bio should explain who you are, what you do, add a dash of your personality and then leave the reader with confidence in you. The days are gone when we relied only on our boring résumés to emphasize our achievements. Unlike a résumé, a bio is less formal. This gives you the opportunity to share your story, build trust and make a positive connection with the reader. A good bio is an important part of your promotional material.

- **Mini:** You will need a mini bio for your social networks and for your elevator pitch. It is a few short sentences.
- **Short:** A short bio needs to have all the components of a long one, but only highlights the very best. Short bios are used for your blog, newsletter, interview, brochures, magazines and query letters. Keep to 100 to 175 words. If it is too long, people won't read it.
- **Long:** A longer bio is used when you feel like you have a lot to say. For instance, such as on your "about me" page of your blog or website. Keep the longer bio to a page in length and consider room for a picture.

Lori's Social Media Tips for Artists

Social media isn't a fad; it's a fundamental shift in the way we communicate. I am a big proponent of social media and its benefits to artists as a free marketing medium. The power of social media enables us to turn our networking contacts into valuable relationships and life-changing opportunities! Here are a few tips to help:

- **Block out time each day** to tweet and update your networks. Focus your efforts where they will have the most impact and keep to your purpose.
- **Be a good follower.** Reach out to those you follow and show your appreciation. Tweet others the way you would like to be tweeted.
- **Network with influencers** in and outside your niche. Aspire to greatness. Rub elbows with those whom you admire and aim to be like.
- **Social media is about giving.** It is about "we," not "me." You cannot expect to receive with a closed fist.
- **Video marketing** will help your website ranking and page results on Google and all other search engines.
- **Compensation comes in many forms.** You might sell artwork via Twitter and Facebook, but more importantly social media provides you with unique business opportunities and relationships that would never happen without this new marketing medium.
- **Twitter is the fastest** way to develop your brand identity and professional image.
- **Twitter is like a cocktail party** where you can quickly meet and exchange information.
- **Facebook is like a dinner party** where you build on conversations and further develop your relationships. You wouldn't just walk up to an acquaintance and say, "Hey, please buy my product." You need to connect and build a relationship first. With social media, the same social etiquette rules apply as in real life.
- **Pinterest is like a social coffee shop**, where people meet and inspire others to buy their product. Pinterest is about eCommerce (social shopping).
- **Instagram** is a great way to use pictures to market your art. Use hashtags to target your audience and gain new followers.

Index

Other fine North Light Books are available from your favorite bookstore, art supply store or online supplier. Visit our website at fwmedia.com.

19 18 17 16 15 5 4 3 2 1

a content + ecommerce company

DISTRIBUTED IN CANADA BY FRASER DIRECT
100 Armstrong Avenue
Georgetown, ON, Canada L7G 5S4
Tel: (905) 877-4411

DISTRIBUTED IN THE U.K. AND EUROPE
BY F&W MEDIA INTERNATIONAL LTD
Brunel House, Forde Close, Newton Abbot, TQ12 4PU, UK
Tel: (+44) 1626 323200, Fax: (+44) 1626 323319
Email: enquiries@fwmedia.com

DISTRIBUTED IN AUSTRALIA BY CAPRICORN LINK
P.O. Box 704, S. Windsor NSW, 2756 Australia
Tel: (02) 4560-1600; Fax: (02) 4577 5288
Email: books@capricornlink.com.au

ISBN 13: 978-1-4403-3922-6

Edited by Mary Burzlaff Bostic
Designed by Geoffrey Raker
Production coordinated by Mark Griffin

Metric Conversion Chart

To convert	to	multiply by
Inches	Centimeters	2.54
Centimeters	Inches	0.4
Feet	Centimeters	30.5
Centimeters	Feet	0.03
Yards	Meters	0.9
Meters	Yards	1.1

About the Author

Lori McNee is a professional artist who specializes in still-life and landscape oil paintings as well as encaustic wax paintings. She is an exhibiting member of Oil Painters of America and Plein Air Painters of Idaho, and serves on the *Plein Air Magazine* Board of Advisors. Lori is a certified Master Artist in Cobra water-mixable oil paints and is an artist ambassador and spokesperson for Arches/Canson/Royal Talens worldwide.

As the owner of FineArtTips.com, Lori blogs about fine art tips, business and social media advice for the aspiring and professional artist. Lori is a social media influencer, ranks as one of the Most Powerful Women on Twitter, and has been featured in FINS of *The Wall Street Journal* and on the BBC, and was named a #TwitterPowerhouse by the Huffington Post. She is also a #SocialTV correspondent, tweeting red carpet events for *Entertainment Tonight*, *The Insider*, *Access Hollywood* and *Vanity Fair*.

Lori is a popular keynote speaker and painting demonstrator who has presented to organizations including Oil Painters of America, Plein Air Convention & Expo, and AME: Artist Materials Expo. She is also a talk show host for *Plum TV* and *ConciergeQ*, and writes for F+W publications including *The Artist's Magazine*, *Artist's & Graphic Designer's Market* and *Photographer's Market*. She also contributed to *Zero to 100,000: Social Media Tips & Tricks for Small Businesses*.

Lori's art has been featured in *Southwest Art*, *American Art Collector*, *Plein Air Magazine*, *Fine Art Connoisseur*, *Western Art Collector*, *Wildlife Art Journal* and *ARTtalk*. Currently, Kneeland Gallery, Dana Gallery, Gardner Colby Galleries and Bella Muse Gallery represent Lori and her paintings.

Acknowledgments

I would like to humbly acknowledge and express my sincere gratitude to my publisher, Jamie Markle, and editor in chief of *The Artist's Magazine* Maureen Bloomfield for recognizing the possibilities within me, and to my editor, Mary Bostic, who patiently helped me conceive, pitch and bring this book to fruition.

Thank you to Chris Burget for introducing me to blogging, and for signing up for Twitter with me on the same day, which led to my writing career! Big gratitude to my brother, Jeff McNee, and my eldest son, Bret McNee, for helping me start my first blog. Thank you to my daughter, Ashley Watson, for her valuable art and literary critiques, and to my youngest son, Craig Watson. Thank you to my studio assistant and daughter-in-law, Taylor McNee.

I would also like to pay tribute to those who have believed in my art career and me: Cyndi, Doug, Daniel, Christine and Brad DuFur, Leslie Manookian McNee, Jake Roometua, Diane Kneeland, Nancy Kneeland, Carey Molter, Igrid Cherry, Candace and Dudley Dana, Debbie and Bill Bunch, R. Scott Nickell, Shanna Kunz, Debbie Edgers Sturges, Elisabeth Pohle, Vickey Hanson-Williams, Colleen and Charles Weaver, Mark Brown, Nancy Winch, Cherie Haas, Kristin Hoerth, Eric Rhoads, Steve Doherty, Kyle Richardson, Arches, Canson and Royal Talens, and the O'Brien family of New Wave Art.

A special thanks to my blog readers and contributors, and to my Twitter, Facebook and social media friends for your valuable tweets and networking, including Adam Leipzig, Tod Hardin, Sean Gardner, Lori Moreno, Sebastian St. George, Greg Wilson, Terri Nakamura, Sarah Jayne and Dean Gratton, Bryan Moore, Ann Tran and more!

I am profoundly thankful to my many mentors and the Old Masters who came before me, and of course to Ed Brickler, Jeff Legg, Joe Anna Arnett, Robert K. Carsten, Elizabeth Robbins, Robert Moore, Shanna Kunz, Ken Auster, Brent Cotton, Michael Godfrey, Kim Casebeer, Romona Youngquist, John D. Cogan, Jill Stefani Wagner, Steven Lee Adams, Christine Debrosky, Linda St. Clair, Suzie Seerey-Lester, John Seerey-Lester, David Goatley, David Gray, Daniel Sprick and Steven Rosati, who have selflessly shared their knowledge and paintings that grace the pages of this book.

Art Credits

Table of Contents
(top to bottom)
Onions (cropped), Joe Anna Arnett, oil on linen, 20" × 24" (51cm × 61cm)
Contentment (cropped), Brent Cotton, oil on linen, 40" × 48" (102cm × 122cm)
Arctic Express (cropped), John Seerey-Lester, oil on Belgian linen, 24" × 36" (61cm × 91cm)
The Story Teller (cropped), David Gray, oil on canvas, 18" × 24" (46cm × 61cm)

Front Cover
(clockwise starting at top)
Summer Renewal (cropped and reversed), Kim Casebeer, oil on linen, 30" × 40" (76cm × 102cm)
Rogers Farm (cropped), Jill Stefani Wagner, pastel on sanded paper mounted on board, 24" × 18" (61cm × 46cm)
Renegade Rooster (cropped), Linda St. Clair, oil on canvas, 18" × 24" (46cm × 61cm)
Julia, Who Was From Russia (cropped), Daniel Sprick, oil on board, 26" × 28" (66cm × 71cm)
Vegetable Soup (cropped), Joe Anna Arnett, oil on linen, 20" × 24" (51cm × 61cm)

Back Cover
(top to bottom)
Summer (cropped), Robert Moore, oil on canvas, 40" × 30" (102cm × 76cm)
Summer in Venice (cropped), Steven Rosati, oil on linen, 24" × 18" (61cm × 46cm)
Backyard Visitor—Saw-Whet Owl (cropped), Lori McNee, oil on Arches Oil Paper mounted on board, 12" × 16" (30cm × 41cm)

Spine
Addie (cropped), David Gray, oil on panel, 9" × 12" (23cm × 30cm)

Dedication
With reverence, I dedicate this book to my biggest fans, my dad and dearly departed mom for their unconditional love and encouragement of my art spirit.

Ideas. Instruction. Inspiration.

Receive FREE downloadable bonus materials when you sign up for our free newsletter at artistsnetwork.com/Newsletter_Thanks.

Find the latest issues of *The Artist's Magazine* on newsstands, or visit artistsnetwork.com.

These and other fine North Light products are available at your favorite art & craft retailer, bookstore or online supplier. Visit our websites at artistsnetwork.com and artistsnetwork.tv.

Follow North Light Books for the latest news, free wallpapers, free demos and chances to win FREE BOOKS!

Visit artistsnetwork.com and get Jen's North Light Picks!

Get free step-by-step demonstrations along with reviews of the latest books, videos and downloads from Jennifer Lepore, Senior Editor and Online Education Manager at North Light Books.

Get involved

Learn from the experts. Join the conversation on